SYMBOLS OF IDENTITY

KOREAN CERAMICS FROM THE COLLECTION OF CHESTER AND WANDA CHANG

SYMBOLS OF IDENTITY
KOREAN CERAMICS FROM THE COLLECTION OF CHESTER AND WANDA CHANG

CHRISTOPHER LOTIS AND MICHEL D. LEE

ASIAN CULTURAL HISTORY PROGRAM
SMITHSONIAN INSTITUTION

This publication is a product of the Smithsonian's "Korean Cultural and Museum Fund," and has been made possible by the generous financial assistance of the following people:

Mrs. Pung Yoon Chang
Mr. Daewon Kwon and Mrs. Chong J. Kwon

Special thanks for design and printing support to:
U.S.-Korea Arts Foundation (Burke, Virginia)

This book is produced and distributed by:
Asian Cultural History Program
Department of Anthropology
Smithsonian Institution
Washington DC 20560-0112 USA

ISBN: 978-0-9724557-1-8
First Edition. First Printing.

Cataloging-in-Publication Data

Lotis, Christopher J. (Christopher Josef), 1977-
 Symbols of identity : Korean ceramics from the collection
of Chester and Wanda Chang / by Christopher Lotis and
Michel D. Lee. — 1st ed.
 p. cm.
 ISBN-13: 978-0-0724557-1-8
 1. Pottery, Korean. 2. Pottery—Private collections.
3. Chang, Chester—Art collections. 4. Chang, Wanda—
Art collections. I. Lee, Michel D. (Michel Dong), 1980-
NK4168.6.A1 L68 2011

Cover and Book Design by Christopher Lotis.

Photography by Chin Kim and printed courtesy of Chester and Wanda Chang (unless otherwise noted).

The authors are using "BC /AD" era designations in this publication in accordance with the Smithsonian Asian Cultural History Program style sheet.

CONTENTS

FOREWORD

We are delighted to present, within the series of collection-based studies by the Smithsonian's Asian Cultural History Program (ACHP), this volume by Christopher Lotis and Michel D. Lee on the Korean ceramics assembled by Dr. Chester and Mrs. Wanda Chang.

The research for this book was undertaken as part of the Asian Cultural History Program's Korean Heritage project, established and maintained through private donations since 1985 to "support, acquisition, conservation, restoration and exhibition of Korean collections, and to support research on Korea's Heritage and other Korean cultural activities at the Smithsonian Institution." Both authors are Smithsonian researchers who served on the core team that produced the National Museum of Natural History's Korea Gallery, first opened to the public in 2007 and now seen by millions of visitors each year. That exhibition includes a "timeline" consisting primarily of ceramics, along with a few other objects, to illustrate a broad overview of Korean history, with periods corresponding to those used in this catalog. Our choice of ceramics for that purpose was partly a practical choice since they are sturdy and (unlike paintings or textiles) allow continuous display even in the high light levels of a long-term gallery; but it was also made possible by the fact that ceramics have such an iconic status in Korea's cultural representation and identity. As this volume notes, two of the objects in that exhibition were loaned by Dr. and Mrs. Chang. I should add that our work on that exhibition first introduced us all to the breadth and depth of their important private collection.

This theme of the relationship between ceramics and cultural identity is explored in this volume, especially as it relates also to a particular family's collection, and also to the broader study of the personal and social aspects of collecting. The book thus forms a contribution not only to the study of Korea's material heritage but also to Korean-American or Asian-American studies, and to the history of collecting. It will surely be of interest to art as well as social historians, and to all those who appreciate the aesthetic quality of Korea's ceramic art.

The authors' "behind-the-scenes" study of this private collection included the creation of an extensive research database about it, not only the ceramics included in this volume but also paintings, costumes, bronze works, and many other objects that could form the basis for subsequent studies. The collection includes some important twentieth-century ceramics that have not been included within this volume; these await study alongside other works by contemporary artists in this wide-ranging collection. As the authors emphasize, the component of the Chang collection selected for publication here has been extensively tested using thermoluminescence testing. For this reason, these objects constitute an important "type collection" of tested pieces for this type of materials analysis, against which other ceramic works may be compared.

This book should therefore serve as an important reference for work on its topic, as a unique and well-illustrated introduction to this private collection and its significance; and hopefully also as a stimulus for other studies within this and related private collections.

Paul Michael Taylor
Director, Asian Cultural History Program (and)
Curator, The Korea Gallery, National Museum of Natural History
Smithsonian Institution
December 2010

ACKNOWLEDGEMENTS

The authors would like to thank many individuals for their time and assistance with this project. Mrs. Pung Yoon Chang (1918-2010) made the first donation to this project to honor the memory of her grandson, Clarence C. Chang, who passed away on May 7, 2005. This publication is dedicated to his memory, and also to Mrs. Chang who passed away on March 4, 2010.

For their generous financial donation, as well as their time and energy assisting with the project, we sincerely thank Mr. Daewon Kwon and Mrs. Chong J. Kwon. Eight of the pieces featured in this book, (Cats. 15, 44, 60, 61, 67, 71, 72, 76) which were formerly in the Chang family collection, are now a part of Mr. and Mrs. Kwon's collection, having purchased them in auction. We thank them for their kind assistance and for providing access to view, study, and photograph the objects in their collection. These objects are each labeled "Courtesy of Daewon Kwon and Chong J. Kwon" within the catalogue.

We especially thank Dr. Chester Chang and his wife, Wanda Chang for allowing full access to their collection for study and research and for all of the work they have done to allow this book to come to fruition. Chester Chang devoted an enormous amount of time going through each piece with us, making sure we had everything we needed, and recalling his memories of how his family used the ceramics and how his collection was formed over the years.

In November 2009, we lost a colleague and dear friend, Chang-su Cho Houchins (1925-2009). As an East Asian scholar, Houchins was an important and integral member of the Smithsonian National Museum of Natural History's Department of Anthropology for over forty years. She was one of our favorite people and an inspiration to us on both professional and personal levels. Despite battling with cancer, she wished to work on this project and viewed it as an important publication. She provided valuable advice and assistance during the early stages of research for this book.

For their support and assistance to this project we thank Paul Michael Taylor, Director of the Smithsonian's Asian Cultural History Program (ACHP), and Carole Neves, Director of the Smithsonian's Office of Policy and Analysis. For their valuable work and time researching and translating Korean documents we thank ACHP intern, Janet Yoo and visiting scholar, Sungsil Cho. ACHP Program Manager Gregory Shook reviewed drafts and assisted with administrative tasks and ACHP Researcher & Program Specialist Jared Koller helped with database preparation and also reviewed text.

We thank Chin Kim for his excellent work providing professional photography of the objects that appear in this catalogue. Stephanie Lee provided expert graphic design advice during the early stages of the book. Louise Cort from the Smithsonian's Freer Sackler Gallery was very generous with her time and answering our research inquires. Sooki Moon of KI Graphics supplied important assistance with preparing the book for design and printing.

On the British side of the project, we would like to thank Dr. Youngsook Pak (Research Associate, Centre of Korean Studies) and Professor Roderick Whitfield (Professorial Research Associate, Department of the History of Art and Archaeology) at the School of Oriental and African Studies, University of London for giving their time and guidance when reviewing an earlier draft of this catalogue. Eunjin Jeong, Museum of East Asian Art intern, was invaluable for fact checking with both English and Korean sources. We also thank Caroline Ribers for her encouragement throughout the project. Finally, we wish to acknowledge the three anonymous peer reviewers who gave us important input and advice in completing this book.

Symbols of Identity

In 2008, an arsonist destroyed South Korea's Number One National Treasure, Namdaemun (Great South Gate) in Seoul. The heartbreak of this loss for Koreans was incalculable. Officially known as Sungnyemun or, "Gate of Exalted Ceremonies," the structure was originally built in 1398 at the start of Korea's Joseon dynasty and was the oldest wooden building in the city. People gathered around the Gate the morning after the blaze to assess the damage and mourn the loss. One year later, it was reopened to the public for a one-day exhibition. It was announced that the Gate would be rebuilt using wood salvaged from the fire.

Namdaemun had survived over 600 years. It had seen 27 different Joseon rulers, the creation of an indigenous alphabet, the first contact and diplomatic relations with the West, Japanese invasions and occupation, the horrors of war, and the country itself split into North and South. Yet through these times, and as a large bustling city with skyscrapers and cars developed around it, the Gate remained standing as an important cultural monument for present-day Korea. It was originally conceived and built as a South Gate to a wall that surrounded the city of Seoul, which included Dongdaemun (East Gate), Sodaemun (West Gate), and Bukdaemun (North Gate). Namdaemun was an important entryway into the city. When the surrounding wall was eventually removed at the turn of the 20th century, its significance changed and it became a gateway to the past. Namdaemun was not just a historical structure of wood and stone however, it embodied a culture and symbolized the spirit and identity of the Korean people.

Hearing news of the destruction of Namdaemun, Dr. Chester Chang shared the feelings of his fellow

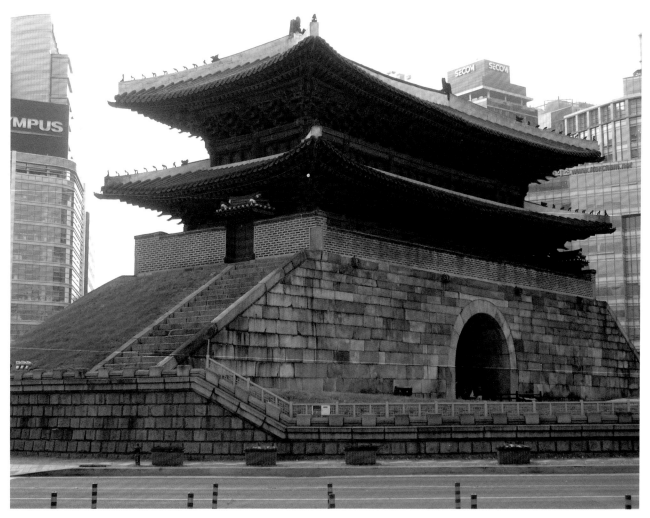

Namdaemun, November 2006.

(Photo by Christopher Lotis)

countrymen, saying in an interview with a Korean news program, "I feel like my heart has a nail through it" (2008). Since emigrating from Korea to the United States in 1948, Chang has always maintained a close bond to his native land. He appreciates and understands the importance of cultural properties and their value to people, having passionately maintained a collection of Korean art and artifacts that has been passed down from his family and that he has added to over the years. In many ways his story begins at Namdaemun, having spent his early childhood years living near the site of the Gate and feeling a sense of pride and a close connection to his ancestral heritage.

Chester Chang was born on February 7, 1939, in Jukdong Palace. His maternal great grandfather, Min Young Whe, was a nephew of Korea's last empress, Queen Min (1851–1895) also known as Empress Myeongseong. Chang's father, Chang Ji-hwan, came to the U.S. as part of a group of representatives to help set up the first Korean

consulate, after the founding of the post-World War II Korean government. Chang Ji-hwan viewed Korean art as an excellent way of communicating and sharing the heritage of his country with many in America who were not familiar with Korean history. The family settled in Los Angeles, California, where Chester Chang would spend many of his formative years. Chang's passion for collecting started, perhaps as many typical American boys of the period, with a collection of coke bottles and baseball cards. In his twenties he began collecting art, with a particular interest in pieces from Korea that would add to his family's collection. His career as an airplane pilot would further enable him to collect pieces from his travels around the world. Chang received graduate degrees from the University of Oklahoma, the University of Southern California, and a Ph.D. in Public Administration from the University of La Verne. In 2009, he was elected to the board of directors of the National Defense University Foundation. He also previously served as a member of the board of trustees

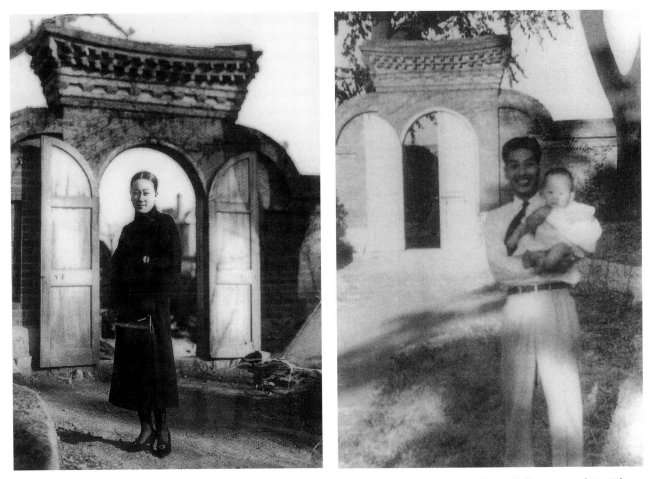

Chester Chang's parents are pictured here next to the Jukdong Palace gate in Seoul: Mrs. Pung Yoon Chang (left) in 1935 and Mr. Ji-hwan Chang (right), holding his son Chester as an infant in 1939.

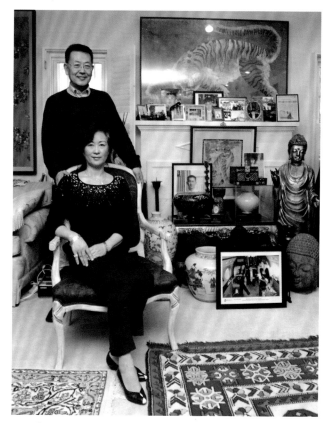

Dr. Chester and Mrs. Wanda Chang (Photo by Eric Sueyoshi)

A 250-year-old eight-panel folding screen, which previously had been loaned to and on display at the Honolulu Academy of Arts, was donated to the Korea Foundation. The screen includes paintings of birds and scenes from Korea's natural landscape accompanied with poems written above each panel. Originally it would have been used in a nobleman's home during the Joseon period. These screens not only carried important symbolic significance to Koreans, for the particular images and scenes depicted on them, but they also served as room dividers and as protection from cool drafts during the winter months. Like Namdaemun, these screens and other works of art from the past are important reminders to Koreans of their cultural traditions and heritage. As Best writes, "Created objects are not . . . mere passive mirrors of the past. They participate in shaping the present moment by affirming and reaffirming through repeated use the cultural values and meanings given expression through them" (1991, 15). For Chester Chang, the donations represent this reaffirmation and provide a gesture of support for his country and the loss that his fellow countrymen experienced with the fire at Namdaemun.

THE CHANG COLLECTION

Located in East Asia, the Korean peninsula is a mountainous region bordering China to the north and Russia to the extreme northeast. The East Sea (or Sea of Japan) and the Korean Strait lie to its east and the Yellow Sea lies to its west. While important influences of government, religion, and styles of art were adopted from China throughout Korea's history, Korea is defined by a unique culture with a distinct language and identity.

In many ways, the identity of a culture is personified in its arts. The Korean ceramics featured in this catalogue are divided into three periods of Korean history: Three Kingdoms and Unified Silla (57 BC–935 AD), Goryeo (918–1392), and Joseon (1392–1910). Buddhism was the main established religion during the Goryeo period, and an inspiration for celadon ceramics such as the *kundika* water sprinkler used in Buddhist ceremonies (see p.45). During the Joseon period, Confucian ideals of simplicity, honesty, and purity are expressed in the white porcelains used for ancestral ceremonies and other everyday purposes. Indigenous folk mythology, or shamanism, is a constant throughout all of Korean

for the Los Angeles County Museum of Art. He has worked for the U.S. Federal Aviation Administration since 1975 and has logged over ten thousand hours of flight time in his career.

In response to the tragic burning of Namdaemun, Chester Chang longed to reach out and help his countrymen, so he resolved to donate artifacts from his collection to Korea. Among his intended donations is a porcelain incense burner which he ceremonially hand carried to the site of the Gate. Cut into the domed lid of the burner are four sets of trigrams (consisting of three parallel bars either solid or broken in the middle). Similar trigrams, originating from ancient Chinese Daoist motifs, can be seen on the South Korean flag today symbolizing heaven, fire, water, and earth. The meaning attached to this small ceramic piece is powerful and important to Chang on many levels. During the Joseon period of Korean history (1392–1910), this incense burner would have been used for ancestral ceremonies. It is now a token of Chang's understanding and desire to help alleviate the pain of this significant symbolic loss to Koreans. (See p.102 for an example of a similar incense burner in the collection).

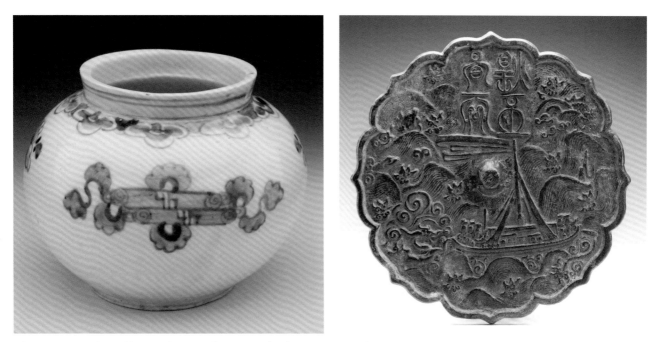

These two pieces, loaned by Dr. Chester and Mrs. Wanda Chang, are currently on display in the Smithsonian National Museum of Natural History's Korea Gallery. The Joseon period porcelain jar (left) and Goreyo period bronze mirror (right) are featured in a historical timeline of Korean history. For a full guide to the exhibition and objects on display see Taylor and Lotis (2008). (Photos by Chip Clark)

history, and these traditions are prevalent in Korean folk art, being incorporated with Buddhist, Daoist, and Confucian motifs.

The identity of an individual may also be personified in his or her collection. In describing why he enjoys collecting, Chester Chang explains, "I collect and share, therefore I am" (pers. comm.). Chang's enthusiasm and love of art are contagious and his ability to share his collection with others is very important to him. His collection includes all types of Asian art including works from China, Japan, and Vietnam, but his strongest connection is to the work from his native land. Pearce submits that, "we are all symbols of ourselves, and objects which, in so many ways, are our *alter egos* are equally symbols of themselves. Collecting becomes a simple, effective way of merging these symbols into broader and deeper meaning" (1998, 184).

Dr. Chester and Mrs. Wanda Chang's collection of Korean art and artifacts is unique and expansive, encompassing ceramics, paintings, lacquerware, stone carvings, bronze pieces, woodcarvings, and furniture. Chang estimates that the collection includes roughly 1,000 pieces, not counting old books, currency, and other smaller items such as court ornaments. It extends across time periods and dynasties, from the earliest periods of Korean history to the modern day. The ceramics that were passed down to him from his family also include Chinese and Japanese ceramics of various time periods.

Chang's collection has been loaned for exhibit and/or gifted to institutions worldwide. He estimates a total of five hundred pieces have been donated over the years, including pieces to the Los Angeles County Museum of Art, the University of Hawaii's Center for Korean Studies, the Kyungwoon Museum's Kyunggi Girls School, the University of Southern California's Korean Studies Institute and School of Social Work, and single items to the Korean National Museum, the Honolulu Academy of Art, and the Korea Foundation.

Chang and his wife began actively donating during the 2003 Korean American Centennial celebration. This was a particularly important occasion to them and millions of Korean Americans, as it marked the anniversary of the first Korean immigrants to arrive in Hawaii in 1903. In 2007, Chang loaned two pieces for display at the Smithsonian's National Museum of Natural History. These pieces, a Goryeo period bronze mirror and a Joseon period porcelain jar with auspicious symbols, became a part of the Smithsonian's Korea Gallery exhibition.

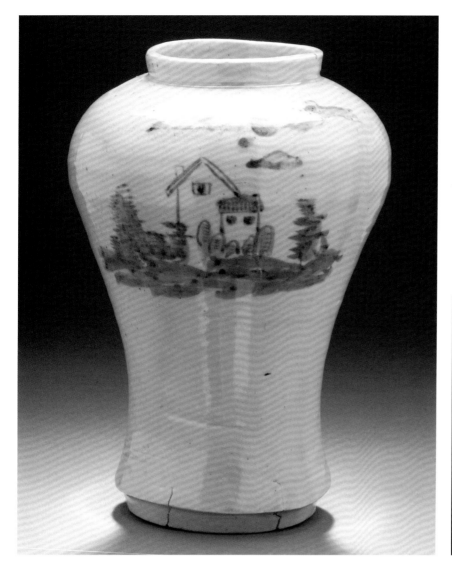

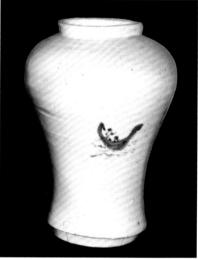

One important gift to the Los Angeles County Museum of Art (LACMA) was a piece donated in loving memory of Chester and Wanda Chang's late son, Clarence. He was tragically killed on May 7, 2005, in Koreatown in Los Angeles while trying to break up a fight between Korean and Vietnamese gangs. As a gesture of peace and to honor his memory, Chester and his wife donated a Vietnamese lacquer Buddha, *The Jina Buddha Amitabha*. Collected sometime in the 1960s while Chang flew in and out of Vietnam as a pilot, this piece now holds deep emotional and personal symbolism. Like his father, Clarence was an airplane pilot and also shared an interest in his family's collection of Korean art.

In 2004, Clarence had donated a twentieth-century porcelain jar to LACMA, which featured a cobalt decoration of European scenes. Chester explained that his son loved the piece because of its meanings and connection of cultures from the East and West. Its inspiration appears to be drawn from different places and time periods, with a shape reminiscent of placenta jars of the Goryeo dynasty and having an indented foot often seen on nineteenth-century Joseon porcelain. Painted on the front of the jar is a Western-style house with chimney. The reverse side is decorated with a single small Venetian gondola, recognizable by its distinctive s-shaped bow ornament, and holding one passenger and a gondolier. The use of minimal decorative elements on the reverse side of a vessel, the gondola in this case, emulates a Chinese porcelain decorative convention sometimes used during the nineteenth and early twentieth centuries.

When asked what his favorite objects or types of objects are from his collection, Chester Chang admits that every piece is a wonderful work of art in its own way. However,

his late son's gift to LACMA is his favorite. For Chang, the ceramic jar is not simply a piece of crafted porcelain, it now carries important personal significance and symbolism for him and his family. Or, to use Chang's own poignant words describing the piece, "it represents so many reasons for existence" (pers. comm.).

THE PRACTICE OF COLLECTING

To understand, interpret, and appreciate a private collection, it is useful to review and discuss some of the broader questions of what it means to be a collector. What constitutes a collection? Why do people collect? How does the collector view or appreciate the collection from an aesthetic or philosophical point of view? How does a collection represent or reflect one's identity?

Pearce provides a general definition of a collection as: "a group of objects, brought together with intention and sharing a common identity of some kind, which is regarded by its owner as, in some sense, special or set apart" (1995, 159). And, as to what signifies the existence of a collection in any given case, Pearce concludes that the best working definition may just be "that a collection exists if its owner thinks it does" (1998, 3). Belk defines collecting as "the process of actively, selectively, and passionately acquiring and possessing things removed from ordinary use and perceived as a part of a set of non-identical objects or experiences" (1995, 479). The passion involved in the process of collecting seems to distinguish what one might call a collector from one simply accumulating things with no special attachment to the acquisition.

In some cases, collecting is merely for financial gain or self-glorification and, as with any potentially all-consuming addictive behavior, there can be many negative after-effects. However, research has also shown that collecting can be a normal, healthy, and happy activity for an individual (e.g., Pearce 1998). There are many explanations as to why people collect and what motivates the collector, just as there are angles and perspectives with which to study the phenomenon of collecting.

Shelton (2001a) groups the scholarly study of collecting into three broad categories: psychological universalizing, historical studies, and a combination of social psychology and history to explore how objects represent self-identity. In her book examining collecting

from a European perspective, Pearce (1995) analyzes the subject from three angles: practice (examining the social practice through time), poetics (how individual collectors define themselves), and politics (how and why collecting or a collection is valued). Some researchers cite specific historical case studies of individuals to formulate their theories, while others have collected data through questionnaires and surveys to test theories and attempt to understand the nature of collecting in the general population. Many have also examined the relationship and differences between a personal, private collection and that of an institution or museum (e.g., Martin 1999; Pearce 1995, 1998; Rigby and Rigby 1944; Shelton 2001a, 2001b; Thomson 2002).

Thomson remarks that, "the business of collecting, whether by individuals or institutions, seems to represent a primitive human trait" (2002, 29). Rigby and Rigby (1944) conjecture that one partial aspect of collecting may stem from a natural instinct of hunting and gathering food for survival and discuss "the collection" as a means to physical security, distinction, immortality, knowledge, and aesthetic satisfaction. They surmise that "the true collector is neither odd nor ordinary; his collecting is at once an art and a response to impulses of great depth" (Rigby and Rigby 1944, 3).

In the book *Collecting in Contemporary Practice*, Pearce (1998) discusses the results of her research which included a postal survey to collect data about collecting habits in contemporary British society. The study found that approximately a third of the population of late 20th century Britain would classify themselves as collectors. Pearce explains that "… collectors are simply proportionately representative of the population as a whole, in broad terms; collectors are merely a segment or a minority group of the whole, and not a separate caste with personal or social defining characteristics" (1998, 46). It was concluded that collecting is not based on socio-economic class, like many cultural practices, but the main differences are found to be gender based. Overall, a higher percentage of women than men was found to identify themselves as collectors. Gender based differences included the different types of things men and women like to collect, how they tend to display their collections, and whether or not they collect additional material that pertains to their collection. Both men and women, however, generally viewed collecting to be an overall positive and satisfying activity in their lives.

Carey (2008) developed an economic model and formula to explain collecting from both a financial and nonfinancial perspective, considering the idea of "set completion" as an important motivation of collecting behavior. McIntosh and Schmeichel (2004) view collecting from a social psychological perspective, and outline eight phases of the collecting process which may include: goal formation, gathering information, planning and courtship, the hunt, acquisition, post-acquisition, manipulation/display/cataloging, and finally, a return to initial goal planning or decision to collect something. The process of setting goals, completing them, and thus receiving positive feedback motivates the collector in this process.

Collecting has also been approached from various psychoanalytic perspectives (e.g., Formanek 1991; Muensterberger 1994). Interested primarily in the motivations of collectors, Formanek (1991) created a questionnaire to find out what influences collectors themselves may attribute to their activities. These motivations were grouped into categories which included: collecting as meaning in relation to the self, to other people, as preserving history, as financial investment, and as addiction. Responses varied not only between collectors but also within individual collectors themselves, who recognized and acknowledged changes in their own motivations over time. This concept of motivations changing throughout life is echoed by Pearce (1998) who also adds that one's social surroundings and culture often play an important role as to whether or not a person perceives his or her self as a collector. Formanek concluded that one common thread in collectors' motivations was the "passion for the particular things collected" (1991, 285).

Danet and Katriel (1989) examined the aspects of play and aesthetics in collecting. They explain that objects collected are reframed, recontextualized, and classified into belonging to a particular category. These items within a category established by the collector are the "same-but-different" with no two items exactly alike. In other words, the objects collected provide a certain visual rhyme to them, that appeal in such a way that a poem cleverly rhymes words. Then there is the satisfaction of ownership and control over the objects collected. Finally, and central to the motivations of collectors in Danet and Katriel's hypothesis, is the desire or pursuit of a sense of closure. Five strategies which collectors may use to this end include: completing a series or set

(see also: Carey 2008; McIntosh and Schmeichel 2004), filling a space, creating a visually pleasing display, manipulating the scale of objects (by choosing to collect large or small objects), and striving for perfect objects (or what one might perceive as "perfect" aesthetically).

Zigrosser describes what he believes are the instincts and motivations of the ultimate or ideal collector and remarks that this "collector does not wish to possess for the sake of possessing but rather to commune again and again with the work of art" (1957, 23). The pure aesthetic enjoyment of collecting for the collector and, in terms of an art collection, the pleasure derived from appreciating the beauty and craftsmanship of objects is another aspect to consider.

Another private Korean art collection, but from a Japanese collector, is chronicled in *The Radiance of Jade and Clarity of Water: Korean Ceramics from the Ataka Collection* (1991). Eiichi Ataka's intense passion for collecting is described by Ikutaro Itoh, who saw Ataka's process of collecting to be an art form in itself. Itoh explained Ataka's criteria for selecting pieces in detail:

> For Ataka, a work of art had to express a sense of tension. No matter how celebrated a work may have been, he would avoid it if it was at all excessive, showy, or vulgar. The objects that appealed to him most had to have dignity, tranquility, and severity, and had to manifest fastidiousness and restraint. It was as though he were searching for human characteristics in the ceramics he collected. (1991, 13)

Like Ataka, Chester Chang also looks for a certain human characteristic in the pieces he collects. What others might see as a flaw in a ceramic piece, such as a misfiring, visible finger marks in the glaze, or irregular, nonsymmetrical form, Chang sees as a mark of uniqueness and artistic beauty.

Japanese philosopher Sōetsu Yanagi (1889–1961) wrote extensively about this particular appreciation for the irregular in terms of a Zen Buddhist philosophy of "thusness" which eliminates the entire concept of perfect or imperfect. Yanagi believed that there was no point to collect anything at all but for the pure reason of beauty alone. He explained that the beauty in Joseon period Korean pottery in particular lies in the work of the unnamed artists who produced the pieces, free of any preconceived notions of what would be beautiful or ugly and no conscious decision to produce something either perfectly symmetrical or intentionally

asymmetrical. Without any regard for what could be defined as perfect or imperfect the pottery created is therefore purely natural. In describing the artistry of Joseon tea bowls, Son Yeong-hak explains, "The finished work didn't have to be a masterpiece. Any shape, whether it was fine or crude, was accepted" (2004, 69). This achievement, from a Zen Buddhist perspective, is the elimination or liberation of all duality and polarization (black/white, beautiful/ugly, good/evil) in one's world view (Yanagi 1972).

Yanagi's writings helped popularize Joseon period ceramics at a time when earlier, Goryeo period art was more valued. Many scholars have discussed and attempted to define and interpret the Korean aesthetic over the years. Some elements described as being embodied in traditional Korean art include: simplicity, naiveté, naturalness, or non-artificiality, shamanism (pertaining to themes and principles of free expression), and humor (Kwon 2007). These themes, in fact, appear in the titles and subtitles of many Korean art books: *Symbolism & Simplicity* (Vos 1997); *Earth, Spirit, Fire* (Roberts and Brand 2000); *Splendor & Simplicity* (Kim 1993); and *The Humour of Korean Tiger* (Zozayong 1970).

In the book *Symbolism & Simplicity*, Vos (1997) describes the Korean art collection of Mr. Won-Kyung Cho. Cho moved to the United States in the late 1950s and, like Chester Chang, he had a keen interest in promoting and preserving Korean cultural heritage. It is very likely that Cho and Chang share similar motivations and attachments to their collections as they both assembled objects that reflect their identity as Koreans.

For Chester and Wanda Chang, their collection of Korean art is in many ways an extension of themselves and their identity as Korean Americans. The objects provide a personal connection and a window into the history of Korean people, apart from the historical commentaries of scholars. When examining a ceramic piece in his collection, for instance, Chang can touch and feel the same shape and weight that his ancestors felt hundreds of years ago. This is an important and powerful aspect to consider when trying to understand what the collection means to the collector. For example, a tangible connection to history and the knowledge acquired through collecting are cited among motivating factors for coin collectors (Case 2009). Also, McIntosh and Schmeichel note that "the objects people collect often are closely connected to their culture in a positive way. . .art objects signify a culture's creative spirit and enlightened nature" (2004, 87).

When asked why he collects, Chester Chang cites pure enjoyment as one reason, family and the significance the pieces have as representations of his heritage as another, and also the ability to pass on his collection for future generations to study and understand. He explains that his motivations and passion for his collection have remained basically consistent throughout his life, adding that the drive to collect might be in his genes. The satisfaction of setting and accomplishing goals is also part of the basic enjoyment, to find pieces, within the categories of his collection (such as paintings or ceramics), which are especially appealing and thus enhance his overall collection. Further, his ability to share his collection with others is also deeply gratifying. Chang explains that looking after his collection is demanding and challenging, and for him it is indeed a serious leisure activity. However, the rewards and satisfactions make it time well spent. Overall, collecting Korean art for Chang is an aesthetic activity as well as educational; it is a continuing journey that is rewarding and enlightening.

THERMOLUMINESCENCE TESTING

In 2007, Chester Chang began a process of scientifically testing some of his ceramic collection using a process known as thermoluminescence testing (TL). TL testing measures the amount of radiation exposed to a particular ceramic piece since it was initially made or last fired. The result is an estimation of the time period when the ceramic was created, accurate by plus or minus twenty percent. In this process, tiny cylindrical cores measuring 3 mm in diameter and 4 mm in length are extracted from a porcelain or stoneware piece, usually in two different unglazed areas of the base (preferably the most inconspicuous areas). These samples are then cut into even smaller slices, one fifth of a millimeter, before finally being tested by specialized equipment in a laboratory setting (Oxford Authentication Ltd). Thermoluminescence is the name given to the faint blue light that is emitted from a sample when it is heated at high temperatures. The more light that is produced by the sample during this heating process, the more radiation it has been exposed to, and thus the greater the age of a piece.

TL testing began in the 1960s and today is a common way to provide a scientific, objective approximation of the date a ceramic piece was made. However, because of the necessity to drill holes in the piece to provide the sample to test, this is also a destructive technique which can decrease the value of a work of art. Over 100 ceramic pieces have been tested in the Chang collection using the TL process. It is unusual for this number of pieces in one collection to have been tested, as usually the test is limited to particular pieces which might be considered questionable. However, for Chester Chang the authenticity was of utmost importance. It outweighed any possible loss of monetary value to any particular piece or the actual damage, aesthetically speaking, to the bottom of the pieces, which in Chang's opinion was nominal. With the art of forgery becoming more and more sophisticated over the years, Chang felt an urgent need to find a way to authenticate his collection objectively. As Bartle and Watling explain,

> The illicit trafficking of cultural material, specifically ancient South-East Asian artifacts, is comparable with the illegal trading of drugs, firearms, and tobacco. . . Experts estimate that *c.* 20% of Chinese material entering the international art market is fraudulent. (2007, 342)

Counterfeiters have also sought many ways to circumvent TL tests such as attempting to artificially irradiate the piece, building an entire new piece around the broken base or loose shards of an ancient piece, or inserting sections of an older, authentic piece in the base of a forgery where they suspect a TL sample might be taken. Because of this, and to control for any other errors, samples are generally taken from two different locations on the base of the piece.

Though Chang explains that he did not have serious doubts about his collection, he wanted to have the extra security and peace of mind that the TL tests would provide. All of the tests on his collection were performed by Oxford Authentication Laboratories in England. Their website explains the process of testing and also explains the usefulness of the test in this context:

> TL is only one tool in the investigation for authenticity. It cannot give the complete picture although it can do many things. It gives an absolute, objective measurement of the time since the clay at the sampling site was fired. In addition it can detect unfired clay and restoration material. If samples are taken from several locations on the piece, TL can indicate if sections are made from a similar clay. As an independent dating tool, it is invaluable.

TL testing does have its limitations, and the results may be influenced by the environmental conditions an object has been through. For instance, a ceramic object that has gone through high or repeated doses of radiation will test older than it actually is and, an object that has been exposed to intense heat may test younger than its actual date of manufacture. TL test results should be treated as evidence rather than as a definitive conclusion.

THE CERAMIC CATALOGUE

The Chang collection includes all types of Korean art and artifacts. This catalogue focuses on the ceramic pieces, which are presented here in a combination of chronological order and typological groupings. The objects range from the early unglazed earthenware of the Silla Kingdom, to the celadon pieces of the Goryeo period, to the porcelains and *buncheong* ware of the Joseon dynasty.

The reasons for this particular focus are multi-fold. Ceramics are an important craft form in Korean history and are intricately tied to the court, aristocracy, and everyday life of the common people. Secondly, because of the sheer volume of the collection, it was more practical to define a particular subject of study for the book. Also, the majority of the ceramics featured in this book were selected by the collector himself to be scientifically tested for authenticity, therefore they hold important significance for him as an individual, above and beyond the larger historical context.

The ceramics in this catalogue were used for all types of purposes from official ceremonies to simple containers for food. They include various shapes and sizes: dishes, bowls, jars, vases, cups, water droppers, brush stands, and incense burners. In some cases, there are even pieces that Chang still uses today. For example, a Joseon period porcelain jar is now used as a vase for flowers (cat. 80), and what was once a brush holder is now used to hold pens and pencils (cat. 94). When his family moved to America, the uses of many of the ceramics evolved, adapting to a new time and place. The ceramics hold important meanings for Chang, for the aesthetic beauty they contain, as representations of his culture, and as a direct tie to his family and ancestors. Many of the family pieces bring back vivid memories of his childhood.

It is Chester Chang's hope that this catalogue of Korean ceramics will inspire others who may not be familiar with Korean culture. Many may know Korea only through the prism of current events and are unaware of its long rich history, traditions and culture, only a part of which, for example, is represented in the 600-year-old Namdaemun. The ceramics in this catalogue provide a window not only into the identity of a culture, but also into the identity of a Korean American, Chester Chang, who kept and cared for these pieces brought over to America by his family and who added to them over the years as an avid collector. The pieces carry important meanings to Chang on different levels, the depth of which might transcend simple metaphor. Understanding this concept also helps to explain the intense emotional reaction of Koreans, such as Chang, when they learned of the destruction of Namdaemun—a Gate which also served as a symbol of their identity.

References

Bartle, E., and R. J. Watling. 2007. Provenance determination of oriental porcelain using laser ablation-inductively coupled plasma-mass spectrometry. *Journal of Forensic Sciences* 52(2): 341-348.

Belk, R. W. 1995. Collecting as luxury consumption: Effects on individuals and households. *Journal of Economic Psychology* 16:477-490.

Best, J. W. 1991. Context of the artistry: A view of the Korean past. In *The Radiance of Jade and the Clarity of Water: Korean Ceramics from the Ataka Collection*, ed. I. Itoh and Y. Mino, 15-26. Chicago: The Art Institute of Chicago. New York: Hudson Hill Press.

Carey, C. 2008. Modeling collecting behavior: The role of set completion. *Journal of Economic Psychology* 29:336-347.

Case, D. O. 2009. Serial Collecting as Leisure, and Coin Collecting in Particular. *Library Trends* 57(4):729-752.

Chang, Chester. 2008. Interview by Gihun Song. *Morning Wide*. SBS, February 18.

Danet, B., and T. Katriel. 1989. No two alike: Play and aesthetics in collecting. *Play and Culture* 2(3): 253-277.

Formanek, R. 1991. Why they collect: Collectors reveal their motivations. *Journal of Social Behaviour and Personality* 6(6):275-286.

Itoh, I. 1991. Korean ceramics in the Ataka collection: The formation of the collection. In *The Radiance of Jade and the Clarity of Water: Korean Ceramics from the Ataka Collection*, ed. I. Itoh and Y. Mino, 11-13. Chicago: The Art Institute of Chicago. New York: Hudson Hill Press.

Kim, H. 1993. *Korean Arts of the Eighteenth Century: Splendor and Simplicity*. New York: Weatherhill: Asia Society Galleries.

Kwon, Young-pil. 2007. "The Aesthetic" in Traditional Korean Art and Its Influence on Modern Life. *Korea Journal* 3: 9-34.

Martin, P. 1999. *Popular Collecting and the Everyday Self: The Reinvention of Museums?* London, New York: Leicester University Press.

McIntosh, W. D., and B. Schmeichel. 2004. Collectors and Collecting: A Social Psychological Perspective. *Leisure Sciences* 26:85-97.

Muensterberger, W. 1994. *Collecting: An Unruly Passion. Psychological Perspectives*. Princeton: Princeton University Press.

Oxford Authentication Laboratories. N.d. Oxford Authentication Ltd FAQs. http://www.oxfordauthentication.com/faqs.htm#p

Pearce, S. M. 1995. *On Collecting: An investigation into collecting in the European tradition. The Collecting Cultures Series*. New York, London: Routledge.

Pearce, S. M. 1998. *Collecting in Contemporary Practice*. London, New Delhi: SAGE Publications. Walnut Creek: Altamira Press.

Rigby, D., and E. Rigby. 1944. *Lock, Stock and Barrel: The Story of Collecting*. Philadelphia: J.B. Lippincott.

Roberts, C., and M. Brand, eds. 2000. *Earth, Spirit, Fire: Korean Masterpieces of the Choson Dynasty (1392-1910)*. Sydney: Powerhouse Publishing.

Shelton, A. 2001a. Introduction: The Return of the Subject. In *Collectors: Expressions of Self and Other*. ed. A. Shelton, 11-22. New York, London: Routledge.

Shelton, A. 2001b. Introduction. 'Doubts Affirmations.' In *Collectors: Individuals and Institutions*. ed. A. Shelton, 13-22. New York, London: Routledge.

Son, Yeong-hak. 2004. *Handicrafts of the Korean People*. Seoul: Dahal Media.

Taylor, P. M., and C. Lotis. 2008. *Flagship of a Fleet: A Korea Gallery Guide*. Washington, DC: Asian Cultural History Program, National Museum of Natural History, Smithsonian Institution.

Thomson, K. S. 2002. *Treasures on earth: Museums, collections and paradoxes*. London: Faber and Faber.

Vos, K. 1997. *Symbolism & Simplicity: Korean art from the collection of Won-Kyung Cho*. Leiden: Hotei Publishing.

Yanagi, S. 1972. *Unknown Craftsman: A Japanese Insight into Beauty*. Tokyo, New York: Kodansha International.

Zigrosser, C. 1957. The Hanley Collection. *Philadelphia Museum of Art Bulletin*. 52(252):23-27.

Zozayong (Cho, Cha-yong). 1970. *The humour of Korean Tiger*. Seoul: Emillle Museum.

ABOUT THE CATALOGUE

This catalogue is divided into three sections: Three Kingdoms/Unified Silla (57 BC–935 AD), Goryeo (918–1392), and Joseon (1392–1910). Each section begins with a brief historical overview and description of the types of ceramics represented in that section. The BC and AD era designations are used in accordance with the Smithsonian Asian Cultural History Program style sheet.

Every object in the catalogue includes a catalogue number, an estimated time period of manufacture based on the style of the piece, thermoluminescence (TL) test results with the approximate time span within which the piece was last fired (based on the test), the type of ceramic (i.e., earthenware, stoneware, or, porcelain), and the measurements of the piece listed in centimeters (representing the maximum dimensions of the object).

Some objects did not have TL tests administered or the results were not available from the collector; therefore there are no TL test results listed for those pieces. The estimated time period of manufacture, based on traditional connoisseurship, generally matches with the TL test results. However, there are some cases where the test results differ from the most likely estimated date of manufacture.

On the right-hand column of each page is a descriptive paragraph about the physical characteristics of the ceramic piece followed by information on the historical context of the piece, its purpose, or how it was likely used. Specific references appear as footnotes and are numbered separately for each catalogue entry. Korean spellings throughout the catalogue follow the Revised Romanization system. Exceptions include words such as "kimchi," where the Romanization has been long been established and accepted. Chinese (Mandarin) words follow the Pinyin Romanization system. Korean terms are either preceded or followed by "Kr" and Chinese terms are either preceded or followed by "Ch" and are placed in parenthesis.

THREE KINGDOMS / UNIFIED SILLA
(57 BC–668 AD) (668–935)

During the Three Kingdoms period of Korean history (57 BC–668 AD), the Korean peninsula was split between three independent states and a smaller federation of chiefdoms named Gaya (42 BC–562 AD). The three kingdoms included Goguryeo (37 BC–668 AD) to the north, Baekje (18 BC–660 AD) to the southwest, and Silla (57 BC–668 AD) to the southeast. Neighboring China has long been a significant cultural and political influence in Korea, especially beginning in the Chinese Han dynasty (206 BC–220 AD) when four Chinese commanderies were established in present-day Manchuria and northern Korea in 108 BC. The Silla kingdom began formal diplomatic relations with China beginning in the late fourth century. By 668, Silla had overtaken the other states in Korea and unified most of the peninsula as one nation for the first time in history, under the title Unified Silla (668–935).

With a government modeled after the Tang dynasty in China (618–907), Unified Silla society was ordered around a strict hereditary class-based system. A societal ranking system known as "bone rank" began in the Silla kingdom with the top level being the *seonggol* or "sacred-bone"—a royal line of the ruling family that would go defunct in the year 654. The next top ranking class was the *jingol* or "true bone" aristocracy, followed by the "head-ranks," and the peasant class or commoners, which contained the majority of the population.

Buddhism, a religion originating in India and imported from China, was the prevailing belief system of the Unified Silla kingdom, influencing the material culture (cat. 8) and legitimizing the power and prestige of rulers. Confucian philosophy was also taught at this time to aristocratic youths. And, as throughout Korean history, shamanism, the indigenous folk belief system based on the spiritual powers of nature, pervaded most of society.

The Korean peninsula was among the earliest regions to master the production of high-fired stoneware, with kiln temperatures reaching 1,200 degrees Celsius, by the third and fourth centuries. However, low-fired earthenware continued to be produced up to the eighth century or later (cat. 8). The eight ceramic pieces featured here from the Three Kingdoms and Unified Silla periods include a figurine, ceremonial vessels, and other jars and pots, some with characteristic combed decorations of wavy lines.

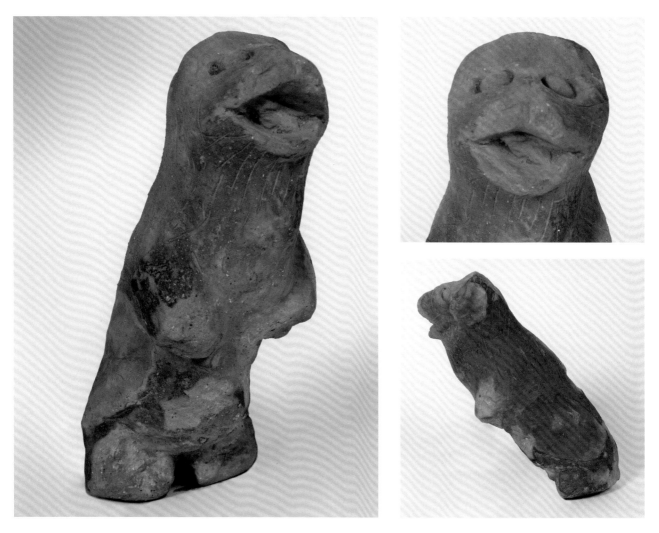

1.
Lion figurine (fragment)
4th–7th century, Three Kingdoms (Silla)
Earthenware
H: 22.5 cm, W: 9.5 cm

Most of the extremities of this gray pottery figurine have been broken off and worn smooth. The figure's mouth, with its snout now partially worn down, is open, and the remains of what may have been a tongue can be seen. Incised lines, representing fur, adorn most of its body. The eyes were made by insetting small, round pieces of clay into the sockets. One side of the animal is stained a rust color.

The breakages on this figurine have mostly worn smooth, and the rust-like staining appears to have occurred after the significant breakages. This suggests the piece was disturbed, fragmented, and weathered while still in the ground. The figure may have been tilled up from the original tomb context through agricultural activity and later picked up from the ground as a surface find.

This animal figure was probably used as a guardian animal for a tomb, with which to keep malevolent forces away. With the limbs now missing, it would have originally sat on its haunches with its front legs holding up its body. Judging by the animal's posture, it most likely represents a lion, the imagery of which came from India via China with Buddhist iconography no later than the fifth century. This is the same posture found in Chinese depictions of lions, often guarding tombs, of the same time period.

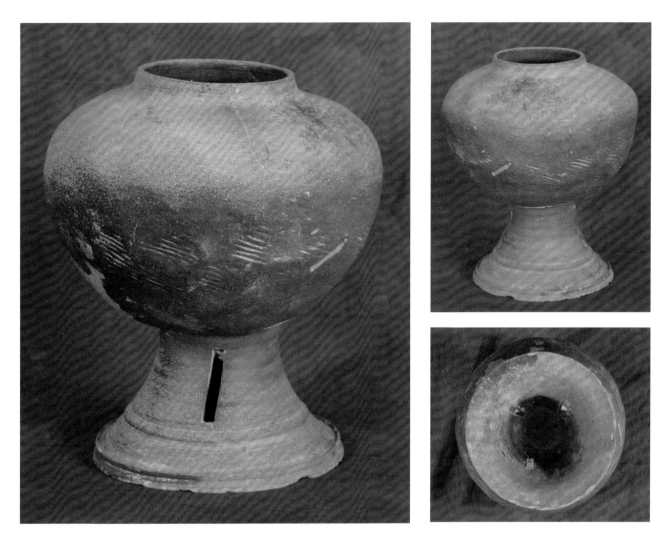

2.
Jar
4th–5th century, Three Kingdoms (Silla)
TL results: *fired between 1,200 & 1,900 years ago*
Earthenware
H: 20.5 cm, W: 17.8 cm

The short neck of this gray-bodied jar opens onto wide shoulders and turns downwards, forming a hemispherical body. Cord impressions are visible on the lower half of the vessel. The pot is attached to an integral stand with three roughly equidistant rectangular slits.

The upper part of this container is much the same as a vessel made for utilitarian purposes. The jar appears to have been constructed by coiling and then shaped further on a potter's wheel. The flat bottom was beaten round with a cord-wrapped paddle on the outside while supported with an anvil on the inside. The stand was potted separately, entirely on a potter's wheel, and attached to the jar before firing. This vessel would originally have had an associated lid.

Vessels with raised pedestals were likely used exclusively for ceremonial purposes during Korea's early history. Not all ceremonial vessels had integral stands. There were also independent stands on which round-bottomed ceremonial vessels could be placed. Tall, pierced stands, probably based on metal forms, were popular during the Three Kingdoms period and became lower and less common during the Unified Silla period. Ceramic vessels with pedestals disappeared during the Goryeo dynasty and appeared again during the Joseon dynasty in the form of high-footed offering wares.

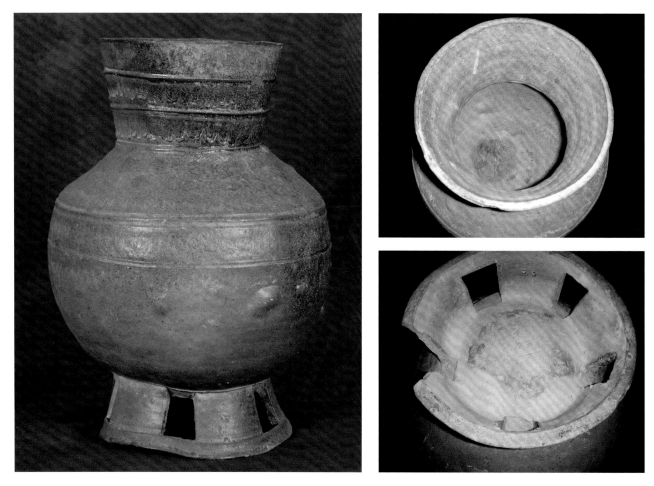

3.
Jar
5th–6th century, Three Kingdoms (Silla)
TL results: *fired between 900 & 1,500 years ago*
Stoneware with natural ash gloss
H: 34.3 cm, W: 25.3 cm

With a wide, flaring mouth and neck, the globular body of this gray stoneware jar with rounded bottom rests on an integral stand pierced with five equidistant, rectangular openings. It is simply decorated with a series of raised parallel latitudinal lines on the neck and middle of the body, separated by wavy combed patterns. Parts of the jar are glossed with a thin layer of unintentional glaze caused by ash that settled on the jar in the kiln during firing. There are firing blisters throughout the body.

This jar likely held grain or a consumable liquid that was buried with the deceased. It may have originally had an associated lid. The pierced stand and raised line ornamentation on this jar suggest it was based on an original made from metal. Gold and silver vessels with similar attached stands have been discovered in Silla tombs in Gyeongju city and are now housed in the Gyeongju National Museum.[1] Some Bronze Age nomadic peoples of the Eurasian steppe also produced bronze vessels with integral pierced stands of similar design. This could possibly be evidence of a link between the common origin of the proto-Koreans and other Altaic-language-speaking migrants from south-central Siberia who spread south and westward. Ceremonial vessels raised on stands or pedestals were common to other Neolithic and Bronze Age (or roughly equivalent) cultures throughout East and mainland Southeast Asia.

1 Catalogue numbers 000305/000, 000309/000, 000310/000, 000317/000, and 000318/000.

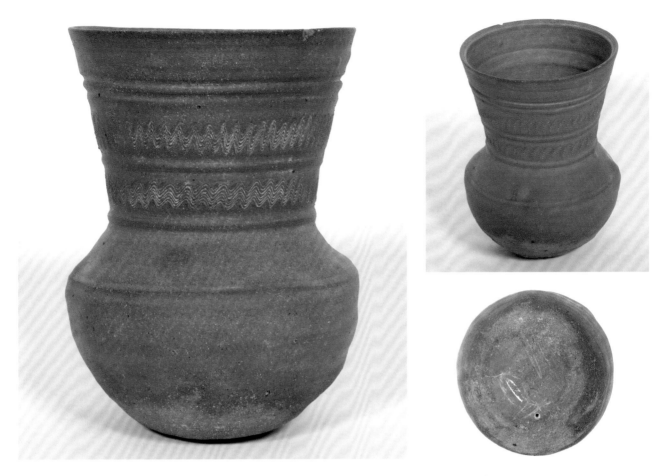

4.
Beaker-shaped vessel
5th–6th century, Three Kingdoms (Silla)
TL results: *fired between 1,000 & 1,700 years ago*
Stoneware
H: 16.5 cm, W: 11.9 cm

The mouth of this vessel is as wide as the widest part of the body. It has a tall neck that tapers to the shoulders, after which the profile slants outward and gently curves inward again to form a base that has been minimally flattened. There are two registers of the standard wavy combed pattern bordered by latitudinal lines. There is another raised line where the slanted shoulder meets the rounded body. Firing blisters are apparent throughout the vessel.

Besides being a funerary vessel, the exact function of this container is unknown. It probably held foodstuffs for the deceased and may have been placed on a stoneware stand with a bowl-like cradle.

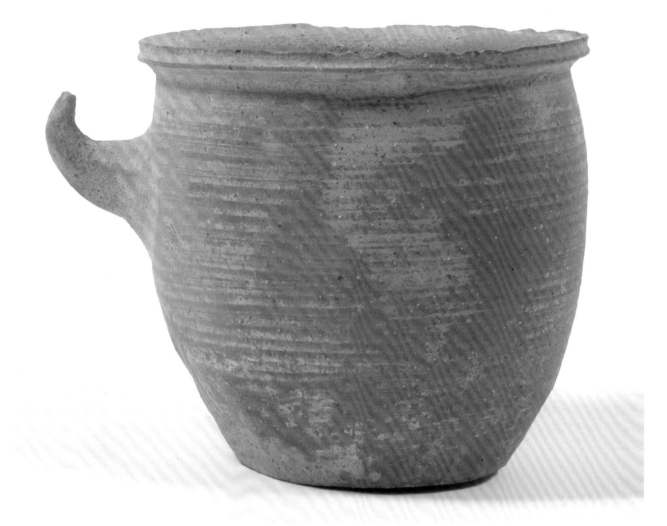

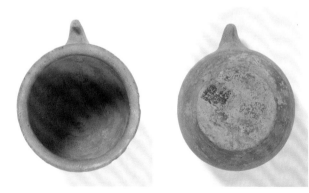

5.
Horn-handled vessel
5th–7th century, Three Kingdoms (Silla)
Earthenware
H: 9.8 cm, W: 12.2 cm

A horn-like knob protrudes from the side of this flat-bottomed vessel. There are shallow grooves that run along the circumference of the body which indicate the vessel was formed on a potter's wheel. The clay of the reddish body material has been tempered with sand.

Earthenware was generally fired at temperatures between 1,000 to 1,200 degrees Celsius. This vessel was likely fired in a bonfire or pit kiln. Sand was sometimes used to temper the clay of earthenware vessels in order to keep it from expanding or contracting too rapidly during the firing process, which can cause cracks in the final product.

The horn-like handle started to appear in pottery on the Korean peninsula during the early Three Kingdoms period (1st-3rd centuries) and continued to be a feature of certain types of vessels into the Unified Silla period. Pottery drinking horns have been discovered in graves from throughout the Three Kingdoms period. This vessel may have held foodstuffs for the deceased, or it may have been a cinerary urn.

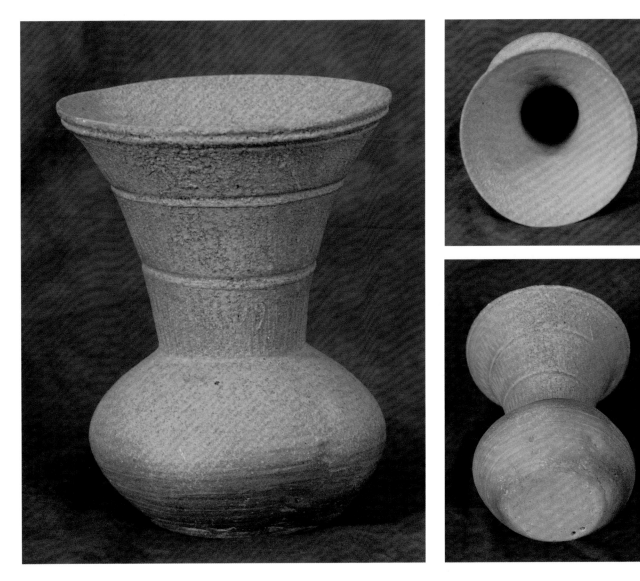

6.
Beaker
Late 7th–8th century, Unified Silla
TL results: *fired between 900 & 1,400 years ago*
Stoneware
H: 17.4 cm, W: 13.3 cm

The trumpeted neck consists of the majority of this vessel. It is separated into three registers demarcated by two impressed lateral lines. Each register is decorated with combed wavy lines. The body resembles a squashed sphere.

This is the same type of beaker as the Silla example, cat. 4, but with a modified shape. The neck has become more flared and the upper and lower hemispheres of the body more symmetrical.

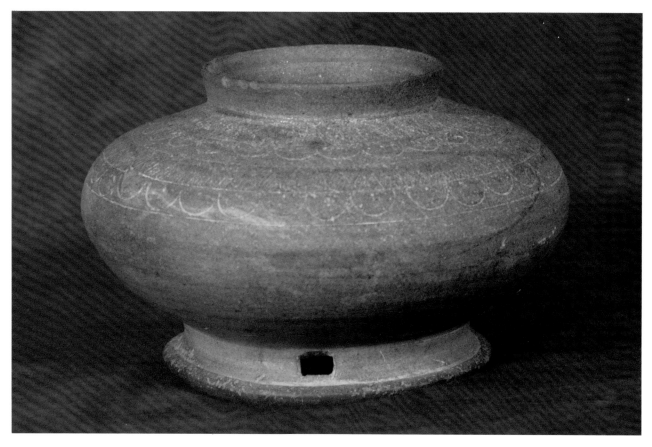

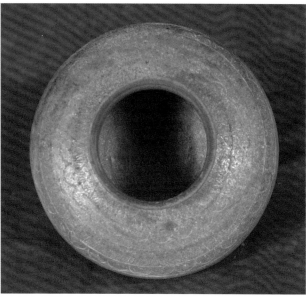

Attached to a flared foot pierced with four equidistant squares, this squat, wheel-thrown jar has impressed designs on the top half of the body. A register of dog-tooth pattern is located just under the short neck; the triangles pointing up filled in with vertical lines. Under this is another register composed of connected scale-like half-circles. This is followed by two more registers of dog-tooth pattern and half-circles, respectively. Much of the vessel is lightly glossed with a thin layer of natural ash glaze.

Although the material is the same as the dark gray stoneware produced during the Three Kingdoms period, the decoration found on Unified Silla stoneware becomes more complex and denser than typically seen on ceramics of the previous period, which are usually decorated with standard horizontal lines and combed patterns. Like cat. 5, this vessel may have contained food staples intended for the deceased, or it may have functioned as a cinerary urn. It once had an associated lid, now lost.

7.
Jar
Late 7th–early 8th century, Unified Silla
TL results: *fired between 1,500 & 2,400 years ago*
Stoneware with natural ash gloss
H: 10.5 cm, W: 16.3 cm

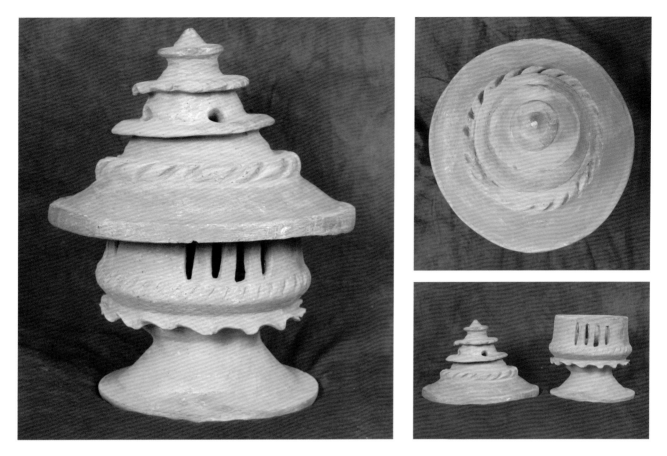

8.
Buddhist incense burner
8th–10th century, Unified Silla–Goryeo
TL results: *fired between 1,000 & 1,600 years ago*
Earthenware
H: 27 cm, W: 23.5 cm

This container is made in two separate parts. The lid is cone-shaped, with three tiers that encircle the top. There are four holes pierced equidistant from each other between the second and third tiers. Below the third tier is a band with diagonal impressions which resembles twisted rope. The lid sits like a roof over the lower portion of the container, which has four sets of four vertical piercings, each set placed equidistant from the other. Below this, near the bottom of the receptacle portion of this piece, are impressed short, diagonal lines. This is followed by a piecrust-like fringe. The receptacle rests atop a flared foot. There are remains of an orange-colored pigment.

Judging by the piercings along the walls of the receptacle and on the lid, this container was most likely used as an incense burner. The three tiers on the lid represent honorific parasols which adorn Buddhist reliquaries, called stupas. The reliquaries, originally Indian in origin, were introduced to Korea with Buddhism. The feature of the three parasols is often found on domed Buddhist reliquaries of the Unified Silla period. A ceramic chimney in the collection of the Harvard Art Museum,[1] made of similar body material and also adorned with the piecrust-like element, is dated from the eighth to tenth century.

1 Harvard Art Museum/Arthur M. Sackler Museum, Partial gift of Maria C. Henderson and partial purchase through the Ernest B. and Helen Pratt Dane Fund for the Acquisition of Oriental Art, 1991.533.

GORYEO DYNASTY (918–1392)

During the demise of the Unified Silla dynasty in the tenth century, the Korean peninsula was again divided among various warring factions. However it was soon reunited under a new ruler, Wang Geon (877–943). He would name the new state Goryeo, after the former Goguryeo kingdom (northern most of the original Three Kingdoms). Today's English name of "Korea" originates from the "Goryeo" name.

The societal "bone-rank" system of Silla was replaced by a "clan-seat" system that linked aristocratic families to their own localities, or place of origin. China was also a prime influence for shaping many aspects of Goryeo culture. Styles of art, poetry, and government organization all were adopted from China. Studying and passing civil service exams, which emphasized knowledge of Chinese writings and Confucian ideology, became important among the ruling class.

Buddhism was the official state religion of the Goryeo dynasty. The complete Buddhist canon was carved into wooden printing blocks in 1087. The Mongolian Empire began repeated invasions in Korea during the thirteenth century and the woodblocks were destroyed during invasions in 1232. They were completed again in 1251 and remain stored in South Korea today in the Haeinsa Temple. The 81,137 woodblocks known as the *Tripitaka Koreana* (Kr: *Palman Daejanggyeong* or *Goryeo Daejanggyeong*) are identified as the 32nd national treasure of Korea. The world's first cast-metal moveable type was also produced during this time. The Mongolian Empire would maintain an indirect control of Korea from 1270 to 1356.

The Goryeo dynasty is highlighted artistically by elegant celadon ceramics. Buddhist monasteries, along with the royal household, were a major patron of high quality ceramics, and religious goods were often made from the green-glazed stoneware (cat. 25). Goryeo celadon copied, and later evolved from, Chinese models from various kilns. Examples of the highest quality feature a brilliant greenish-blue-colored glaze. In Korea, this color was known as *bisaek* (Ch: *feise*), or "kingfisher color." Celadon ceramics often include inlaid decoration which entails carving designs into the unfired clay and filling the depressions with black or white slip to create the design. The celadon cup (cat. 19) pictured on the front and back cover of this book is an example of this and features a popular decorative motif of the period.

The Goryeo ceramics in this catalogue include brownish-green glazed wares ("celadon" of ordinary quality) and celadon bowls, dishes, and bottles. These vessels are decorated with press-molded, stamped, or inlaid designs, or are painted with iron pigment. Others are left undecorated. Examples of unglazed stoneware used for everyday purposes are also featured here.

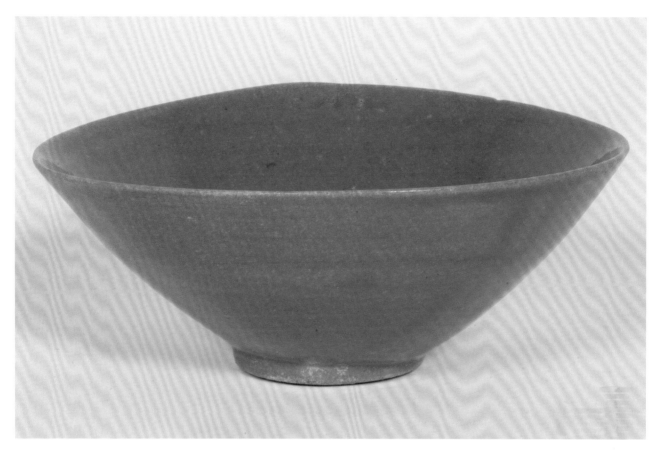

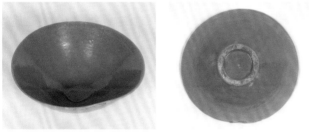

9.
Bowl
Mid 10th–mid 11th century, Goryeo
Stoneware with celadon glaze
H: 6 cm, W: 15.5 cm

Conical in shape, this undecorated bowl has slightly bulging sides. The bowl is completely coated in a celadon glaze that has fired an olive color. Five kiln scars can be seen on the broad footrim, where it was supported on five clay pads when being fired in the kiln.

This bowl represents the early phase of celadon production in Korea, when the potters were closely copying Chinese prototypes. The shape, glaze, and technique of glazing the entire vessel are all following examples of contemporary products of the Yue kilns in Zhejiang Province, southeastern China.

Following Chinese technology, Korean potters often used clay pads or silica chips to elevate a vessel inside the kiln. This helped to keep the melting glaze from fusing to the firing surface during the firing process. The blemishes the kiln furniture causes are called kiln scars.

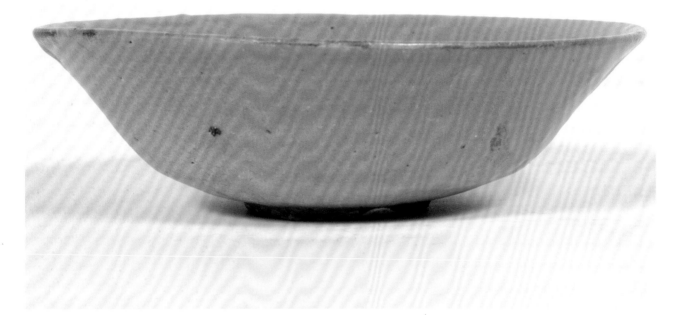

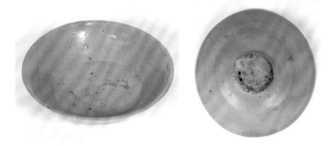

10.
Bowl
12th–13th century, Goryeo
TL results: *fired between 800 & 1,200 years ago*
Stoneware with celadon glaze
H: 4.8 cm, W: 15.5 cm

This shallow bowl is unadorned with surface decoration. The well of the vessel is relatively flat, breaking at an angle when the wall flares up and out. Three unglazed finger marks are located about three-fifths down the outside walls. The footrim is mostly glazed. The base is also glazed and has adhesions of kiln grit.

The form of this vessel is one of the common bowl shapes, following Chinese models, during the twelfth century in Korea. Unglazed finger marks can sometimes be seen on glazed Korean ceramics and indicate where the vessel was held by the fingers when being coated with glaze. Besides clay pads and silica chips, kiln grit—composed of coarse sand—was also used to keep the glaze from adhering to the surface during the firing process.

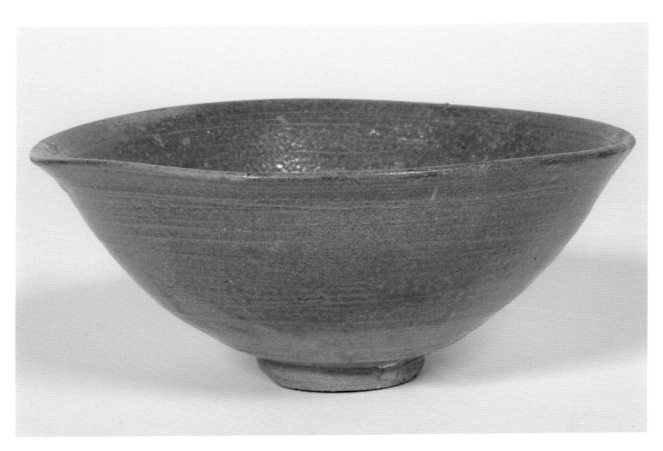

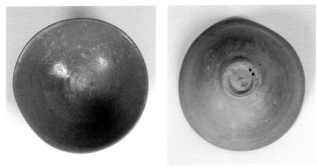

L eft undecorated, this simple bowl with gently curving walls is coated in a thin layer of curdled celadon glaze. The base is glazed but not the beveled footrim, which reveals a gray body material. The bowl was fired on sand, the remains of which can be seen on the base and footrim.

Utilitarian bowls such as this could have been used for either eating or drinking.

11.
Bowl
11th–12th century, Goryeo
TL results: *fired between 500 & 900 years ago*
Stoneware with celadon glaze
H: 7.7 cm, W: 18.6 cm

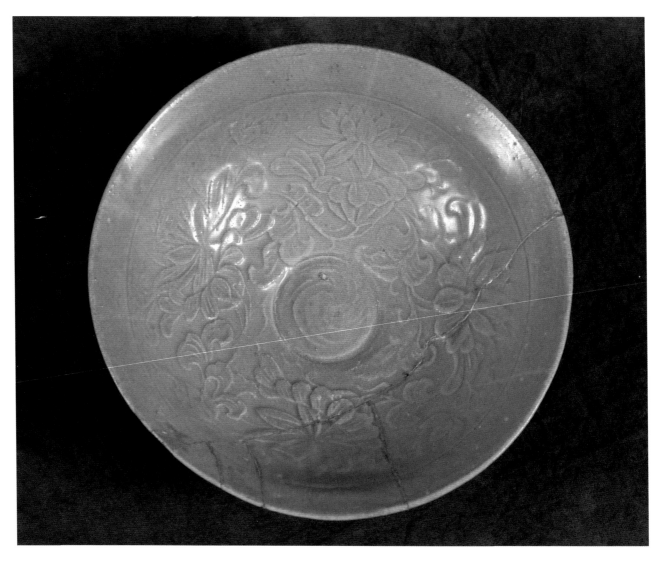

12.
Bowl
First half of 12th century, Goryeo
TL results: *fired between 900 & 1,400 years ago*
Stoneware with impressed designs under celadon glaze and
gold lacquer repair
H: 6.1 cm, W: 18.2 cm

This bowl with flared lip has press-molded designs of lotus plants and a central swirl motif under celadon glaze. The lip and outside surface of the bowl are left undecorated. The vessel was fired on four clay pads, the scars of which can be seen on the footrim and reveal the light gray body material. Except for the firing scars on the footrim, the bowl was completely coated in glaze. Gold lacquer has been used to repair this vessel.

Early Goryeo celadon usually copied products from Chinese kilns. This bowl took its design from contemporary wares made in the Yaozhou kilns. Like the design of many Chinese bowls of this period, the lip was left undecorated. The lotus motif entered Korea from China with the introduction of Buddhism. Although originally associated with the Buddhist religion, the lotus motif became popular by the Goryeo dynasty and decorated nonreligious wares as well. It became a symbol of fertility because of its prominent seedpods.

At some point, probably during excavation, the bowl was broken into five pieces and repaired with the traditional Japanese *kintsugi* (gold joinery) technique, which employed gold lacquer. The bowl was acquired by the collector in Japan during the 1960s or 70s.

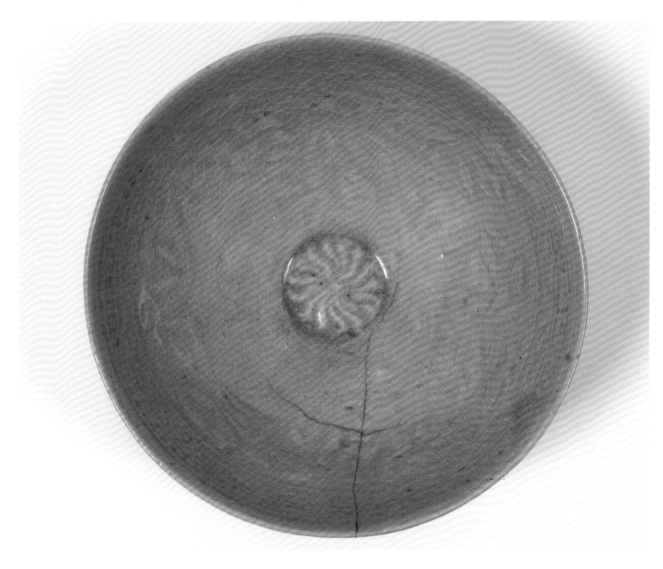

13.
Bowl
First half of 12th century, Goryeo
TL results: *fired between 800 & 1,200 years ago*
Stoneware with impressed designs under celadon glaze and
gold lacquer repair
H: 7.6 cm, W: 18.7 cm

This bowl has faint press-molded designs. A crack, originating from the side of the vessel, has been reinforced with Japanese gold lacquer. The bowl is completely glazed and fired on three silica chips, the scars of which can be seen on the base.

The press-mold used to decorate this bowl must have been past its prime at the time of the bowl's manufacture. The designs are faint and generally unrecognizable. However, the decoration appears to be mainly floral or vegetal motifs copying contemporary designs from China. The glazed foot-rim and its thinness are reminiscent of Chinese Ding and *qingbai* wares.

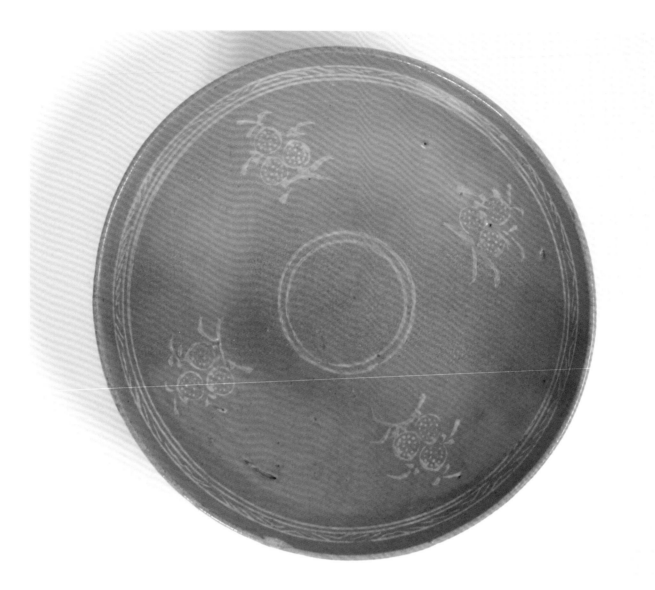

14.
Bowl
13th century, Goryeo
TL results: *fired between 600 & 1,000 years ago*
Stoneware with inlaid designs under celadon glaze
H: 6.7 cm, W: 21 cm

Relatively sparsely decorated, this bowl has a stylized grass-like design on the inside of the bowl, just below the lip, followed by four evenly spaced bunches of three ly-chees. Two concentric rings encircle the bottom of the well. The outside of the bowl is decorated by four equally spaced chrysanthemum flowers enclosed within double rings, all contained within two sets of double lines that run around the circumference of the bowl. The base and footrim are glazed. The scars from three silica chips can be seen on the base.

The technique of inlaying celadon started in Korea around the middle of the twelfth century and is one of the mile-stones of Korean ceramic technology. The inlays were pro-duced by first incising, carving, or stamping depressions into the unfired clay body. White or black slip (a clay slurry) was brushed into the depression and allowed to dry. The surface of the clay body was then scraped with a tool to remove the excess slip, and the vessel was then glazed, dried, and fired.

Lychees symbolize the wish for establishing sons, for male heirs continued the family line. Bowls of this form were probably used for consuming liquids.

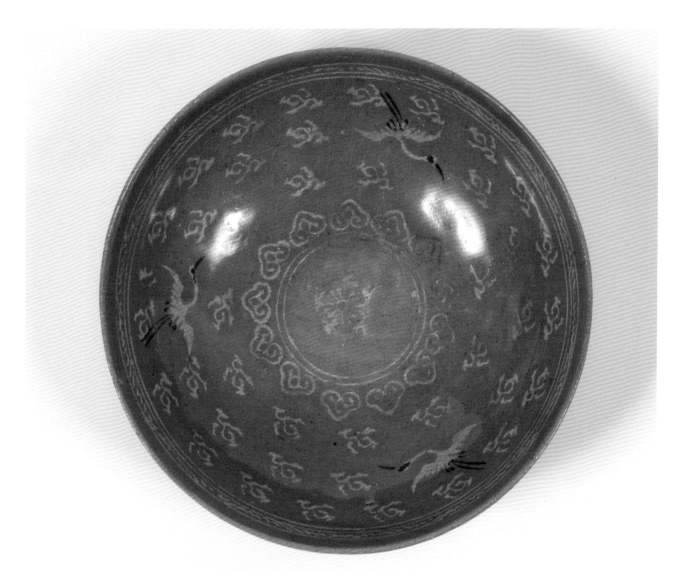

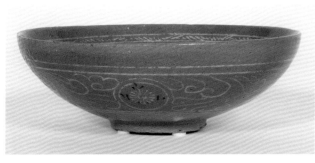

15.
Bowl
13th–first half of 14th century, Goryeo
TL results: *fired between 600 & 1,000 years ago*
Stoneware with inlaid designs under celadon glaze
H: 6.2 cm, W: 19.3 cm
Courtesy of Daewon Kwon and Chong J. Kwon

This celadon glazed bowl is decorated with stylized grass patterns near the lip on the inside of the bowl, followed by three cranes flying amid stylized clouds that resemble birds in flight. The central medallion is a chrysanthemum flower surrounded by a double ring and a collar of *yeo ui* (Ch: *rúyì*) heads. The outside of the bowl is decorated with four evenly spaced chrysanthemum flowers, with leaves inlaid in black, inside a band of streaky clouds, or perhaps a visualization of wind. The base has been mostly wiped free of glaze and has adhesions of kiln grit.

A common bird depicted in Korean art, cranes are a symbol of longevity. When represented as a pair, they stand for marital harmony, as cranes were thought to mate for life. The *yeo ui* design, a popular motif found on Goryeo celadons, originates in China and is a general symbol for well-wishing. The name of the motif means, "as you wish."

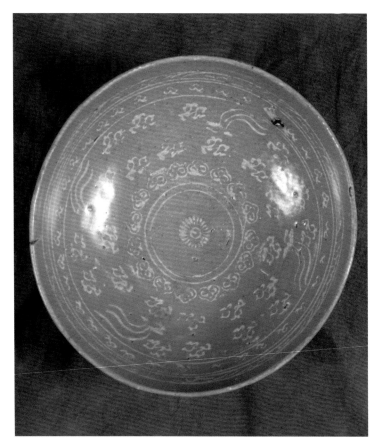

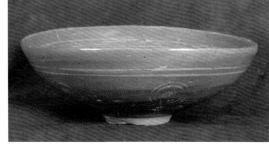

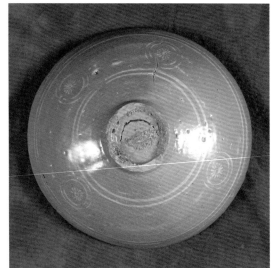

16.
Bowl
Second half of 13th–first half of 14th century, Goryeo
TL results: *fired between 600 & 1,000 years ago*
Stoneware with inlaid designs under celadon glaze
H: 7.1 cm, W: 19.4 cm

This bowl with curved sides is decorated only in white inlay. The majority of the designs are stamped, and the overall impression is one of declining quality when compared to inlaid celadon wares of the twelfth century, reflecting the twilight years of the Goryeo dynasty. The inside of the bowl, near the lip, is decorated with a narrow band of stylized grass pattern followed by another narrow band of stylized clouds. The main register depicts four phoenixes flying amid larger stylized clouds. The central medallion is composed of a single chrysanthemum encircled by double rings and a ring of *yeo ui* (Ch: *rúyi*) heads. The outside wall is decorated with four medallions of chrysanthemums encircled by double rings. The medallions are bordered by parallel lines, above and below, that run along the circumference of the bowl. The footrim is largely chipped; the base is glazed and has adhesions of kiln grit. The glaze is pock-marked and firing cracks appear on the lip, outside wall, and base.

The footrim was glazed, but much of the glaze has chipped, revealing the unoxidized, gray body material. The damage was due to glaze fusing to the surface on which it was set during firing. Therefore, the bowl had to be pulled off the surface once the glaze cooled and solidified. By the end of the thirteenth century, the execution and design of inlaid celadon becomes more haphazard and mechanical when compared to earlier examples (compare with cats. 17 & 21). The predominance of stamped, as opposed to carved, decoration heralds the development of inlaid *buncheong* wares in the fifteenth century. Phoenixes, which often decorate Goryeo celadon, are auspicious creatures and considered good omens.

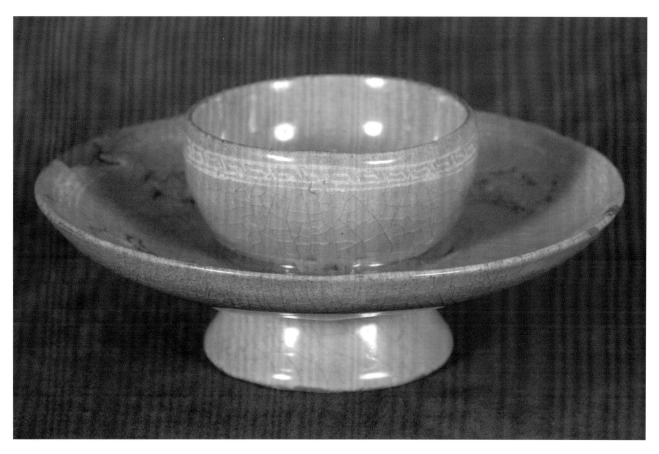

17.
Cup stand
Second half of 12th century, Goryeo
TL results: *fired between 300 & 500 years ago*
Stoneware with inlaid designs under celadon glaze and
gold lacquer repair
H: 6.6 cm W: 15.3 cm

Composed of three integral parts, this cup stand has a cradle, a saucer-like middle section, and a flaring foot on which the stand rests. The outside rim of the cradle is decorated with "thunder patterns" inlaid in white, as is the edge of the disk. Four pairs of inlaid chrysanthemums are spread equidistant from each other around the disk. The center of the cup stand is hollow—from the cradle through to the foot. The footrim is free of glaze. Two small sections on the lip of the saucer were chipped and filled in with gold lacquer.

A handleless cup would have been held in the cradle of this stand. The saucer portion helped to facilitate the handling of the cup when drinking hot tea and kept the fingers from being burned. The designs of cup stands in Korea come from Chinese prototypes and are generally of two types: those which have a cradle and are hollow through the center, such as this example, and those which have a raised, flat platform, replacing the cradle. Chrysanthemums are a common decorative motif found on inlaid celadon of the Goryeo dynasty and are considered flowers of luck.

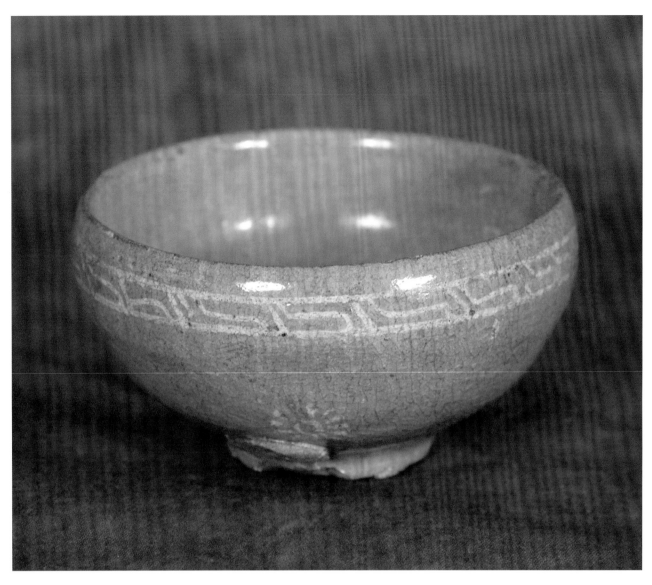

This celadon cup with curved sides has a plain interior. The outside wall is decorated with a "thunder pattern" band near the lip and three chrysanthemum flowers spaced equidistant from each other. The base and footrim are glazed. Four firing scars are evident on the underside.

18.
Cup
Late 12th–13th century, Goryeo
TL results: *fired between 800 & 1,200 years ago*
Stoneware with celadon glaze
H: 5.6 cm, W: 9.7 cm

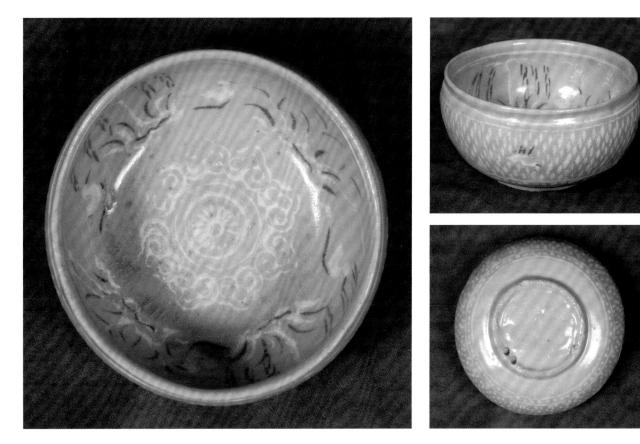

19.
Cup
13th–mid 14th century, Goryeo
TL results: *fired between 700 & 1,100 years ago*
Stoneware with inlaid designs under celadon glaze
H: 4.9 cm, W: 8.7 cm

With slightly bulging sides and indented lip, this cup is decorated on the inner wall with scenes of waterfowl swimming among reeds and willow trees. The central medallion is formed by a stamped and inlaid design of a chrysanthemum flower surrounded by *yeo ui* (Ch: *rúyì*) heads. The outer surface of the bowl is decorated with cranes flying amid what are probably stylized clouds. Below that is a narrow band of closely spaced dots. The thick base is glazed, and the footrim has a thin layer of glaze. Faint kiln scars can be seen on the footrim.

The indented lip of this cup may have been inspired by contemporary Chinese tea bowl design. The scene of waterfowl swimming among aquatic plants is a common motif found on Goryeo objects of various mediums and may have evolved from Chinese painting compositions of the same theme. The collector vividly remembers his grandparents using this cup to drink from.

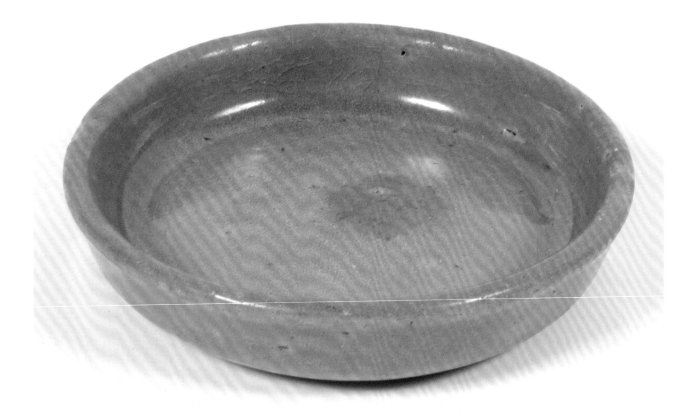

This small dish has a rolled lip and is completely coated in celadon glaze. The scars from three or four silica chips on which the dish was fired can be seen on the base.

The brownish blemish inside, near the center, may have been caused by something resting on the dish during burial and staining it.

20.
Dish
12th century, Goryeo
TL results: *fired between 600 & 1,000 years ago*
Stoneware with celadon glaze
H: 2.5 cm, W: 11.11 cm

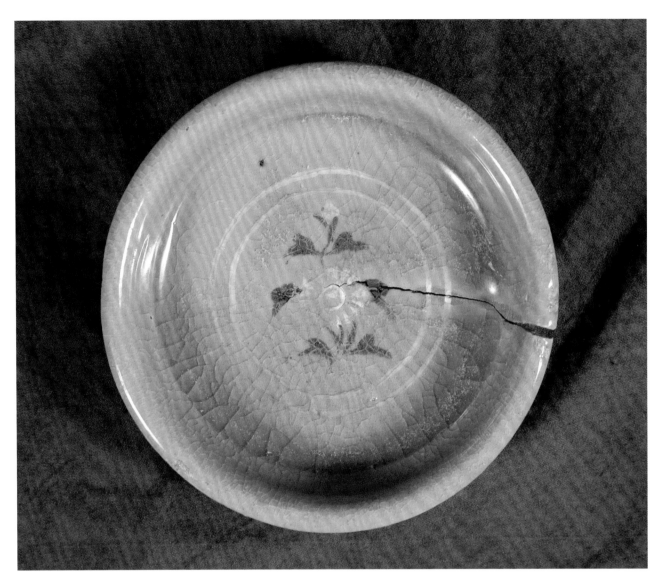

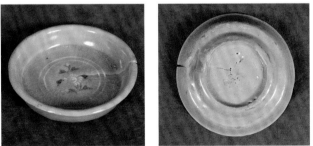

21.
Dish
Second half of 12th century, Goryeo
TL results: *fired between 600 & 1,000 years ago*
Stoneware with inlaid designs under celadon glaze
H: 3.2 cm, W: 11.9 cm

Of similar shape as cat. 20, this vessel has an added inlaid decoration of a chrysanthemum surrounded by a double ring in the well. Except for a few gaps, it is completely glazed, and scars from three silica chips are apparent on the base. A large firing crack runs from the lip to the center of the dish.

The prominent crack in this dish suggests this piece was a kiln-waster, or a piece which became faulty during the firing process and would have been discarded after it was taken from the kiln. If this were indeed the case, then this dish would have been discovered among other failed remnants of ceramics at the kiln site.

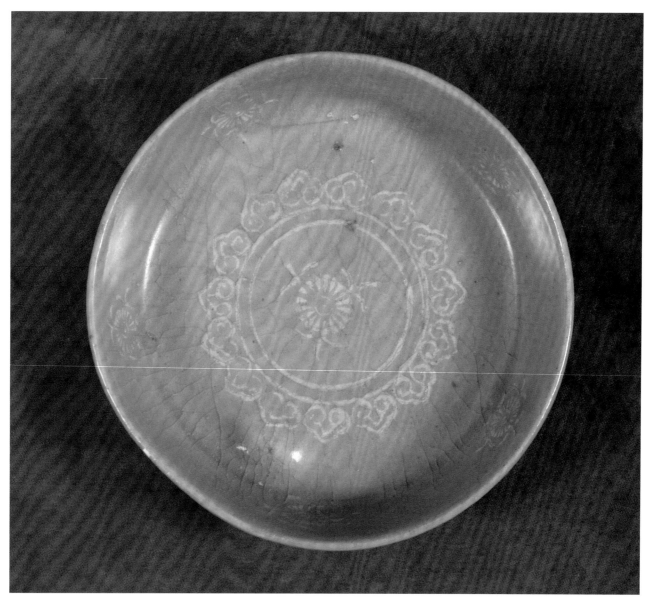

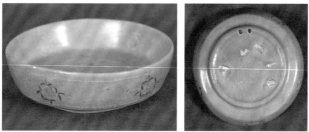

The center of this thick-based dish is decorated with a chrysanthemum surrounded by a double ring enclosed by a collar of *yeo ui* (Ch: *rúyi*) heads. The inside wall contains five evenly spaced chrysanthemums. The outside wall also has five evenly spaced chrysanthemums, this time with the leaves inlaid in black. The dish, including the footrim, is completely covered in celadon glaze. Six unevenly spaced scars caused by silica chips are apparent on the base. A firing blister bubbles up on the well, near the inside wall.

22.
Dish
13th–14th century, Goryeo
TL results: *fired between 600 & 1,000 years ago*
Stoneware with inlaid designs under celadon glaze
H: 3.5 cm, W: 11.3 cm

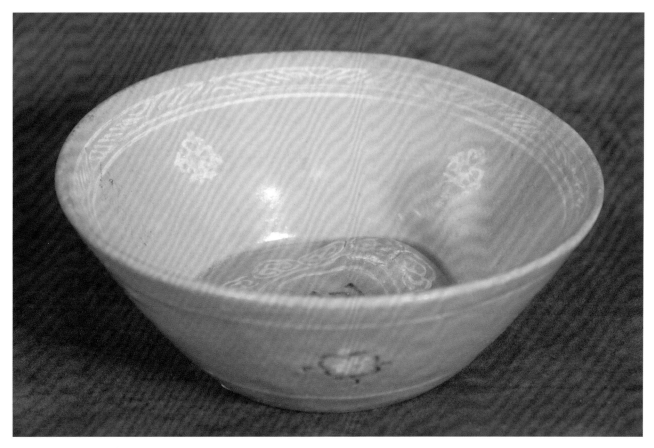

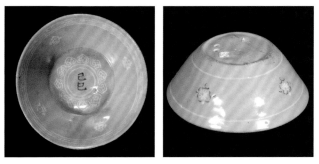

23.
Bowl
14th century (1329), Goryeo
TL results: *fired between 600 & 1,000 years ago*
Stoneware with inlaid designs under celadon glaze
H: 5.1 cm, W: 13.5 cm

Of conical shape, this bowl is decorated with black and white inlays under celadon glaze. The inner rim has a narrow band of stylized grass-like pattern, followed by four stylized chrysanthemums spaced equidistant from each other. Two inlaid black Chinese characters in the well indicate a cyclical date and are surrounded by a double ring and *yeo ui* (Ch: *rúyi*) heads. Four evenly spaced chrysanthemums decorate the outer wall, with leaves inlaid in black, between two thin lines that run the circumference of the dish. The base is glazed and slightly recessed, and the footrim is mostly glazed. The bowl was fired on three silica chips, the scars of which can be seen on the base. Two firing blisters are located near where the well meets the inside wall.

Goryeo celadon bowls and dishes are sometimes inlaid with a Chinese cyclical date in the well. Traditionally, these wares were attributed to the thirteenth century. However, new archaeological and historical evidence now make a fourteenth century date more likely.[1] Chinese cyclical dates are composed of one of ten characters designated as "heavenly branches" combined with one of twelve "earthly stems" in combinations that add up to a sixty-year cycle. The combination of the Chinese characters *gi* (Ch: *jĭ*) and *sa* (Ch: *sì*) can indicate 1269, 1329, etc., though 1329 may be the more likely dating.

1 Yong-i Yun, "Introduction: Part II Celadon stonewares of the Koryŏ Dynasty," in *Korean Art from the Gompertz and Other Collections in the Fitzwilliam Museum: A Complete Catalogue*, ed. Regina Krahl (Cambridge: Cambridge University Press, 2006), 54.

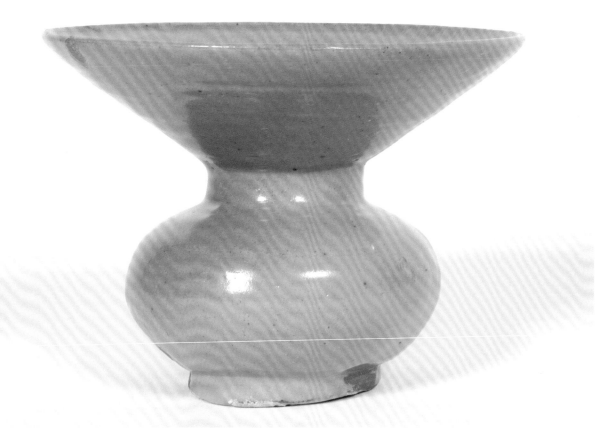

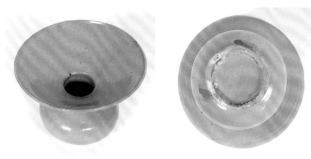

24.
Waste receptacle
12th century, Goryeo
Stoneware with celadon glaze
H: 13 cm, W: 17.2 cm

The wide, funnel-like upper section of this receptacle is shaped like a conical bowl. It has been luted at the short neck to a slightly squashed, bulbous body. The footrim and base are coated with the greenish-blue translucent glaze. There are kiln scars left by clay pads on the footrim. Two small, unglazed patches are located just above the footrim.

The design of this vessel was copied from contemporary Chinese examples. Scholars of Chinese ceramics sometimes suggest these vessels were used as spittoons or for disposing of tea or wine dregs.[1] Korean scholars usually narrow their function down to being waste receptacles for the latter beverage only.[2] However, there does not seem to be any definitive proof for the exact use of this type of vessel. A similar receptacle, described by a modern scholar as a "celadon ritual wine emptier," has been discovered in the tomb of King Myeongjong (r. 1170-1197, died in 1202) and now housed in the National Museum of Korea, Seoul.[3] It has an added spout inserted into the body. The two unglazed patches above the footrim of the vessel in this catalogue entry may be where fingers held the vessel when it was dipped into the liquid glaze.

1 Robert D. Mowry, *Hare's Fur, Tortoiseshell, and Partridge Feathers: Chinese Brown- and Black-glazed Ceramics, 400-1400* (Cambridge: Harvard University Art Museums, 1996), 92.

2 Kumja Paik Kim, *The Art of Korea: Highlights from the Collection of San Francisco's Asian Art Museum* (San Francisco: Asian Art Museum – Chong Moon Lee Center for Asian Art and Culture, 2006), 92; Geon Choi, *Togi Chengja [Stonewares and Celadons]*, Korean Art Book vol. I (Seoul: Yekyoung, 2000), 180.

3 Lee Ae-ryung, "Chapter II: Ceramics from Goryeo Royal Tombs," in *Royal Ceramics of Goryeo Dynasty*, ed. Kwak Dong-seok (Seoul: National Museum of Korea, 2009), 36, 41.

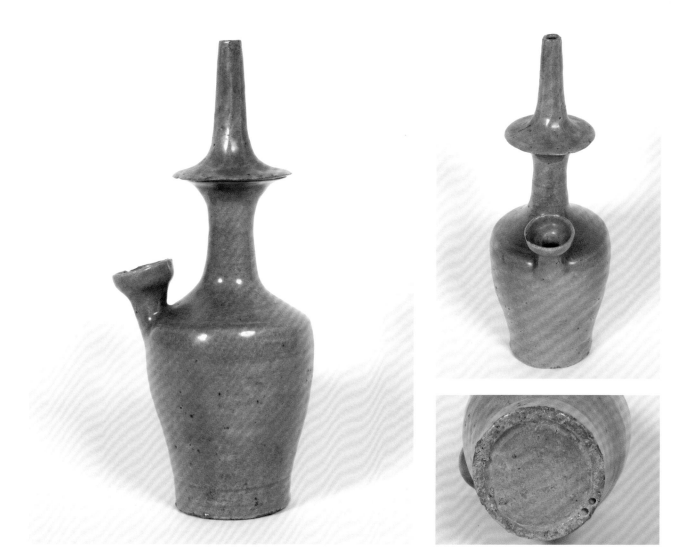

25.
Kundika
12th century, Goryeo
TL results: *fired between 600 & 1,000 years ago*
Stoneware with celadon glaze
H: 32.5 cm, W: 14.4 cm

This vessel is coated in olive-colored glaze and topped with a narrow, faceted, tubular spout that flares down into a disk and contracts again to form the neck of the bottle. The tubular spout is made from two sections that join at the underside of the disk. The flat, slanting shoulder drops down into a slightly swelling body, which tapers gently into a waist on a faintly flared foot. Another opening stems from the shoulder with a dish-shaped mouth. The base is glazed within the coarse footrim.

Originally a metal vessel of Indian origin, a *kundika* (Kr: *jeongbyeong*, Ch: *jìngpíng*) is a Buddhist ritual vessel used to hold "pure" water for ceremonial offerings. However, by the first half of the twelfth century in Korea, its nonreligious use as a water container spread to a diverse cross-section of society.[1] The vessel form was brought to Korea from China as early as the Unified Silla period and was made in large numbers during the Goryeo dynasty. Metal versions of this type of bottle were also used in both China and Korea. The bottle would have been filled through the opening with the dish-shaped mouth.

1 Ikutaro Itoh, *The Radiance of Jade and the Clarity of Water: Korean Ceramics from the Ataka Collection* (Chicago: The Art Institute of Chicago, 1991), 44.

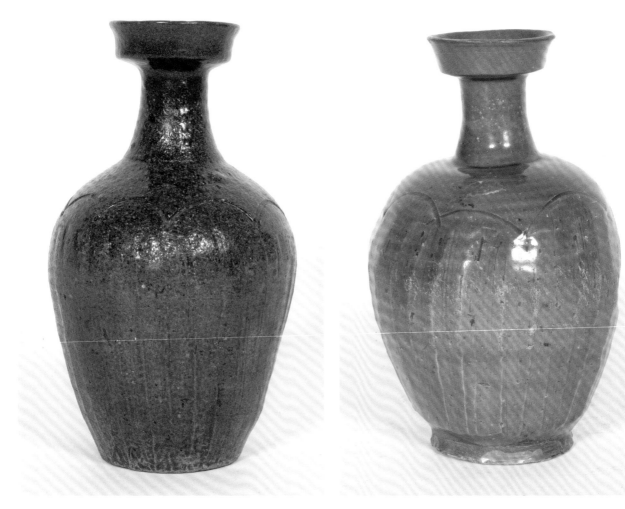

26.
Bottle
10th–11th century, Goryeo
TL results: *fired between 600 & 1,100 years ago*
Stoneware with brownish-greenish glaze
H: 26.6 cm, W: 16 cm

27.
Bottle
10th–11th century, Goryeo
TL results: *fired between 600 & 1,000 years ago*
Stoneware with celadon glaze
H: 24.8 cm, W: 15.2 cm

Of typical Goryeo dish-mouthed bottle form, these two vessels are decorated with what may be a large lotus leaf around each of the bodies. Catalogue 26 is coated in a mottled brownish-green glaze with a flat and unglazed base. Catalogue 27 has an olive-colored celadon glaze and rests on a low, splayed foot. The center of the base is glazed, with the surrounding areas of the base and the footrim being wiped free of glaze.

The leaf pattern which decorates these bottles was made by making vertical cuts on the sides of the vessels at an angle, with a potter's knife. This was done before the bottle was fired. The top border was then incised with arcs to complete the leaf design. The flared foot of cat. 27 may be an influence of Chinese Yue wares, which often copied designs of vessels made from silver.

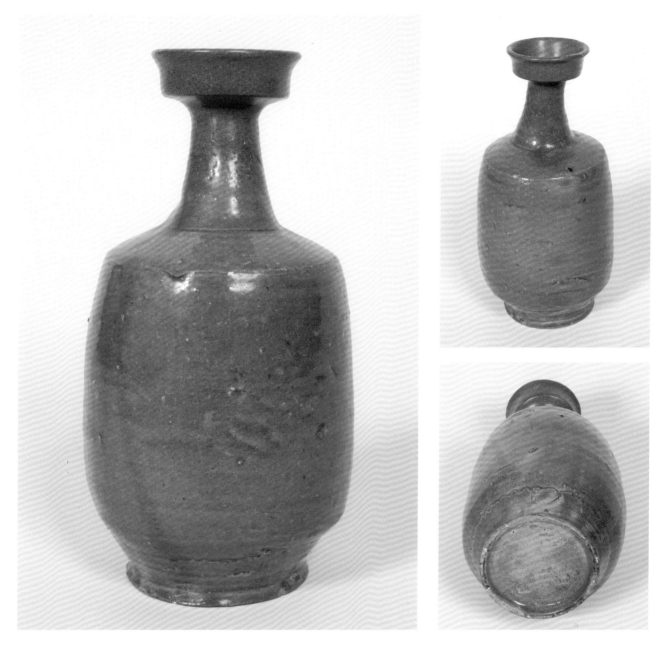

28.
Bottle
10th–12th century, Goryeo
TL results: *fired between 700 & 1,200 years ago*
Stoneware with celadon glaze
H: 27.2 cm, W: 14.6 cm

The dish-shaped mouth of this bottle rests on a cone-like neck. Shoulders straight and slightly slanting downwards, the body drops down at an angle, bulging faintly, and tapers at another angle near the short, splayed foot. The base is partially coated in glaze, but the footrim was wiped free of glaze.

The flared foot may have been influenced by products of the Yue kilns in China, which often copied the forms of silver vessels. The dish-shaped mouth, which developed from Chinese ceramics design, acted as a funnel, facilitating the pouring of liquids into the bottle. This type of bottle was used to hold beverages such as wine.

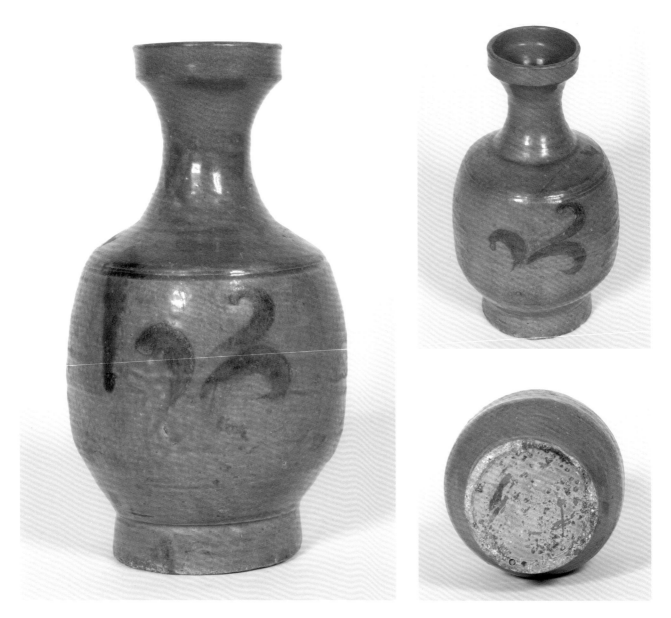

29.
Bottle
Mid 11th–13th century, Goryeo
TL results: *fired between 800 & 1,200 years ago*
Stoneware with iron oxide decoration under celadon glaze
H: 26.1 cm, W: 14.8 cm

With a dish-shaped mouth and rather square shoulders, this bottle rests on a relatively high foot. It is coated with olive-colored glaze and painted with simple vegetal motifs on opposing sides of the bottle, each executed with three calligraphic brush strokes painted with iron oxide pigment. The footrim and base are partially glazed. Much of the kiln grit used to keep the glaze from sticking to the firing surface remains adhered to the base.

A bronze example of this bottle form is held in the collection of the Harvard Art Museum.[1] The somewhat angular transitions in the shape of this vessel suggest the design for this bottle came from a metalware original.

1 Harvard Art Museum/Arthur M. Sackler Museum, Gift of Namhi Kim Wagner, 2003.289.

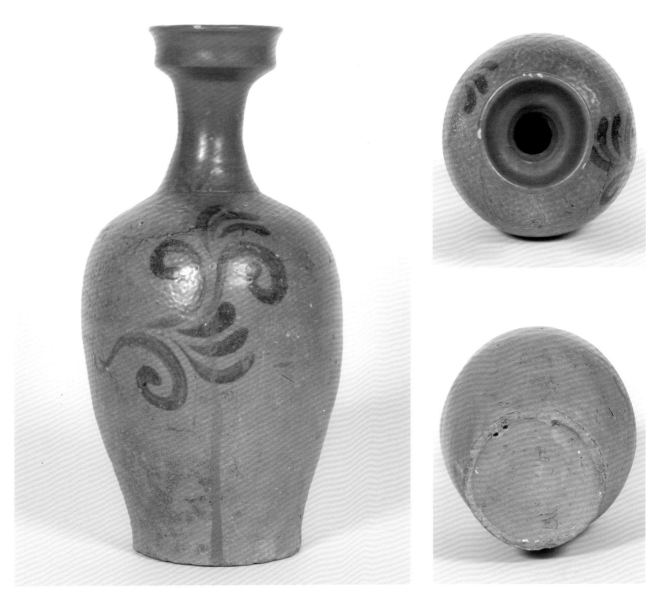

30.
Bottle
Mid 11th–mid 12th century, Goryeo
TL results: *fired between 700 & 1,200 years ago*
Stoneware with iron oxide decoration under celadon glaze
H: 28.9 cm, W: 15.3 cm

Fluidly drawn vegetal sprays are painted in iron oxide on two sides of this dish-mouthed bottle. The mottled olive green glaze was fired unevenly, which has obscured the painting on one side. The footrim and shallow base are unglazed. The mouth and much of the neck have been restored on this bottle, using the original pieces.

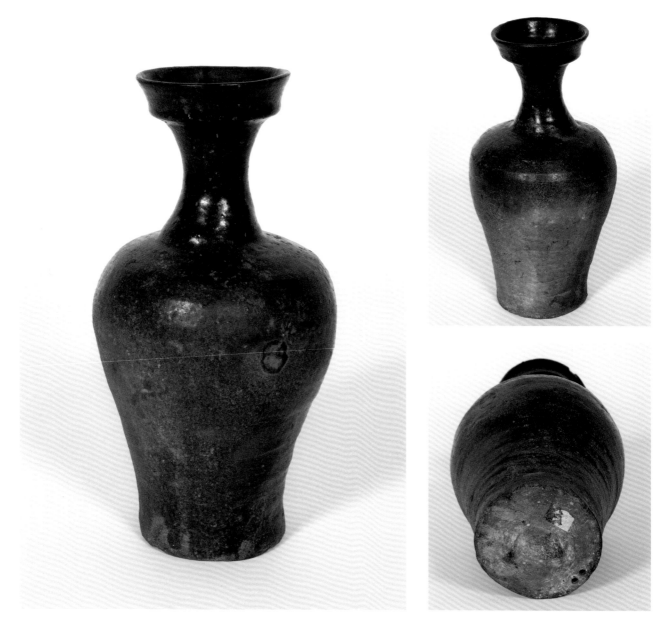

31.
Bottle
11th–12th century, Goryeo
TL results: *fired between 600 & 1,000 years ago*
Stoneware with greenish-brown glaze
H: 26.3 cm, W: 13.8 cm

With an unevenly applied layer of dark olive-colored glaze, this bottle has a dish-shaped mouth, broad shoulders, and a slightly flaring foot. The base is flat and unglazed.

The type of glaze on this bottle was probably made by combining kiln ash and slip, which fires to a greenish-brown or dark olive color.[1]

1 Hongnam Kim, *Korea's Third Ceramic Tradition: From Earthenware to Onggi* (Seoul: Ewha Womans University, 2000), 96.

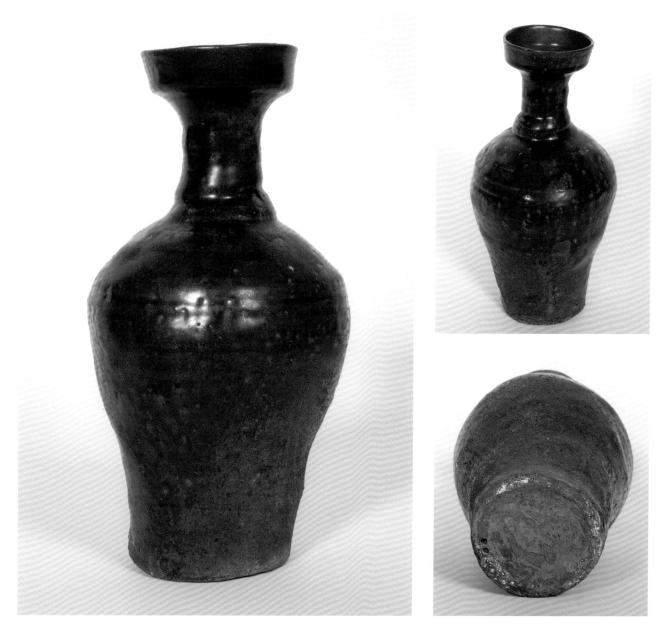

32.
Bottle
11th–12th century, Goryeo
Stoneware with greenish-brown glaze
H: 30 cm, W: 16.2 cm

This dark olive green-glazed bottle has a dish-shaped mouth that funnels into the neck, opens into broad, round shoulders, and contracts at the waist. The faint footrim appears to have been formed by pressing into the base with the fingers rather than cut with a potter's knife. The uneven base is slightly concave and has been wiped free of glaze.

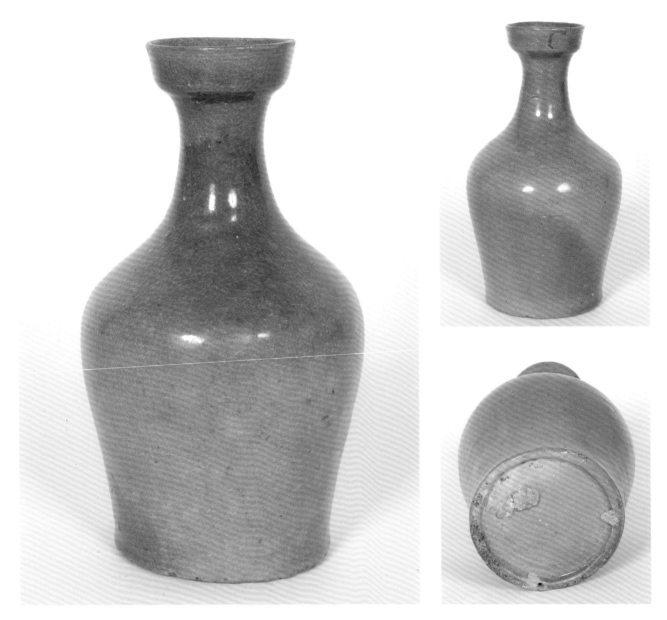

33.
Bottle
12th–13th century, Goryeo
TL results: *fired between 600 & 1,000 years ago*
Stoneware with celadon glaze
H: 25.5 cm, W: 14.6 cm

Coated in an unevenly fired celadon glaze, with colors ranging from brownish-olive to a bluish-green, this relatively heavily potted bottle has a dish-shaped mouth above a neck that spreads onto slumping and rounded shoulders, tapering slightly, and ending with a broad base. The base and footrim are glazed. Three scars left by the clay pads on which the bottle was fired can be seen on the base and footrim. There are also remains of kiln grit on part of the footrim. The exposed areas of the body that were not originally covered with glaze oxidized a reddish color, though the unexposed body material is actually gray.

In order to fire a celadon glaze of even and ideal color, a subtle bluish or grayish-green, the wares must be fired in a well-controlled reduction atmosphere, meaning the process by which oxidation is prevented by the removal of oxygen within the kiln. If the atmospheric conditions are not kept consistent within the kiln, the glaze color will become uneven, such as on this piece.

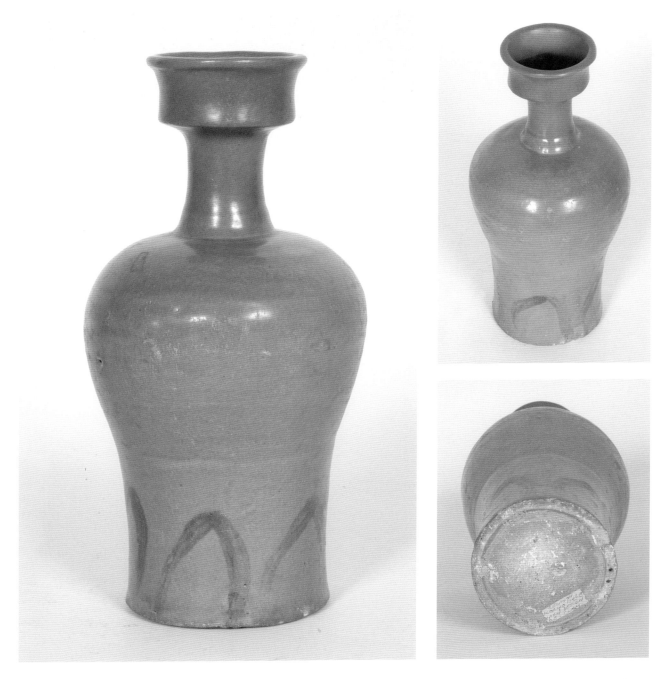

34.
Bottle
12th–13th century, Goryeo
TL results: *fired between 600 & 1,000 years ago*
Stoneware with iron oxide decoration under celadon glaze
H: 29.8 cm, W: 15.6 cm

Coated in celadon glaze, this robustly shaped bottle has a dish-shaped mouth attached to a neck that opens onto broad shoulders and contracts at the waist, flaring slightly to the base. Simple lotus petals are painted in underglaze iron oxide below the waist. The base within the footrim is coated with a thin layer of glaze. Evidence of five clay pads used to support the vessel during firing can be seen on the footrim.

Celadon wares decorated with iron oxide were fired in a neutral to oxidizing atmosphere, which resulted in a yellowish or brownish-toned glaze.

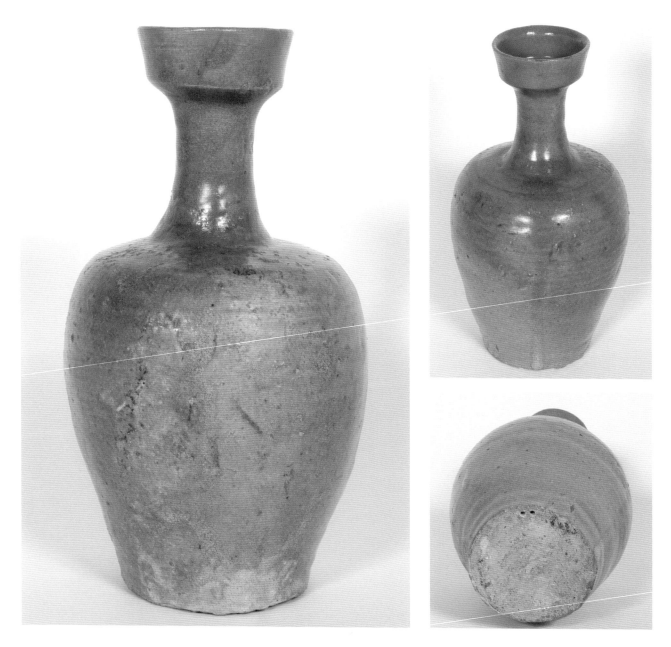

35.
Bottle
12th–13th century, Goryeo
TL results: *fired between 600 & 1,100 years ago*
Stoneware with celadon glaze
H: 27.8 cm, W: 16.1 cm

The mottled glaze of this bottle with a dish-shaped mouth ranges in color from a bluish-green to olive. The base is flat, unglazed, and has evidence of three clay pads on which the bottle was fired.

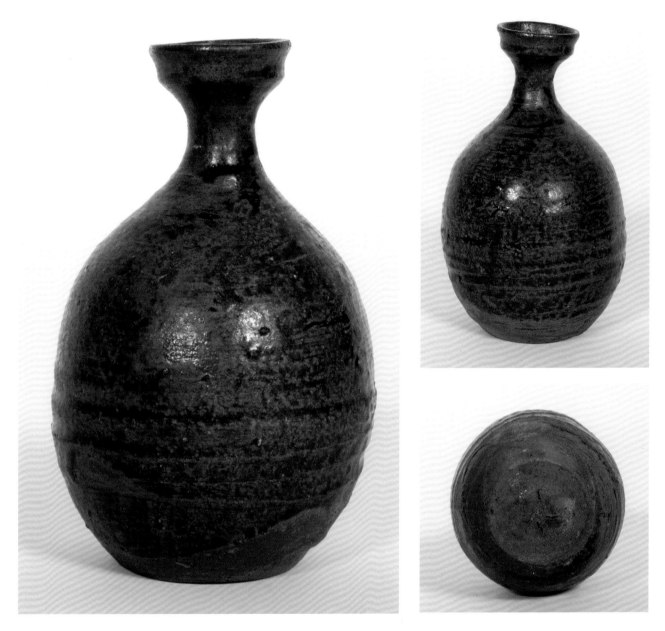

36.
Bottle
11th–13th century, Goryeo
Stoneware with brownish-green glaze
H: 16.3 cm, W: 10.2 cm

With a dish-shaped mouth, the body of this bottle is ovular in shape, almost cocoon-like. It is coated with a mottled, brownish-green glaze that reaches nearly to the flat base. The otherwise gray body material has fired to a brownish-red color on the exposed surfaces during firing.

Judging by its size, this bottle was used for pouring alcohol. It is too small to contain any meaningful amount of nonalcoholic beverage.

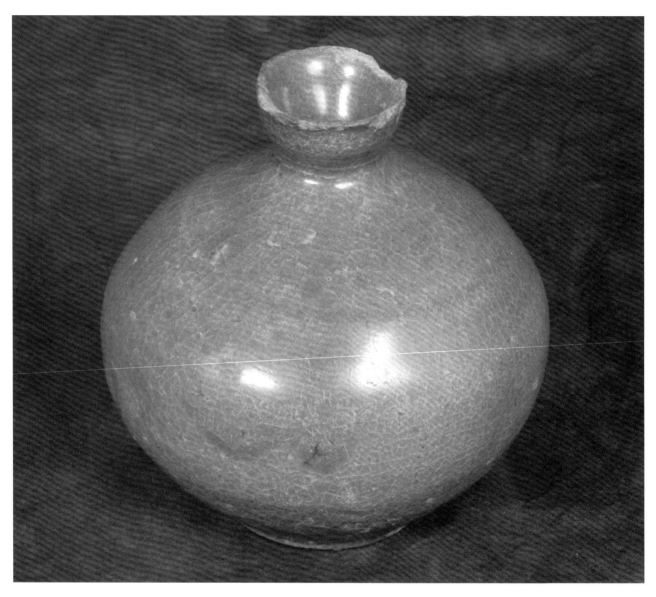

37.
Oil bottle
11th–12th century, Goryeo
TL results: *fired between 600 & 1,000 years ago*
Stoneware with celadon glaze
H: 11.2 cm, W: 11.2 cm

Of bulbous form with a small, dish-shaped mouth and short, constricted neck, this oil bottle is coated in celadon glaze. The base is glazed within the footrim and has kiln scars resulting from four clay pads. This bottle probably once had an accompanying stopper.

Small oil bottles held scented oils and were used by women from wealthy families to oil their hair and bodies. Earlier examples such as this are more globular in form. Small, squat oil bottles, which could be accommodated within ceramic boxes along with other small ceramic cosmetic containers, were fashionable during the height of celadon production in Korea in the twelfth and thirteenth centuries.

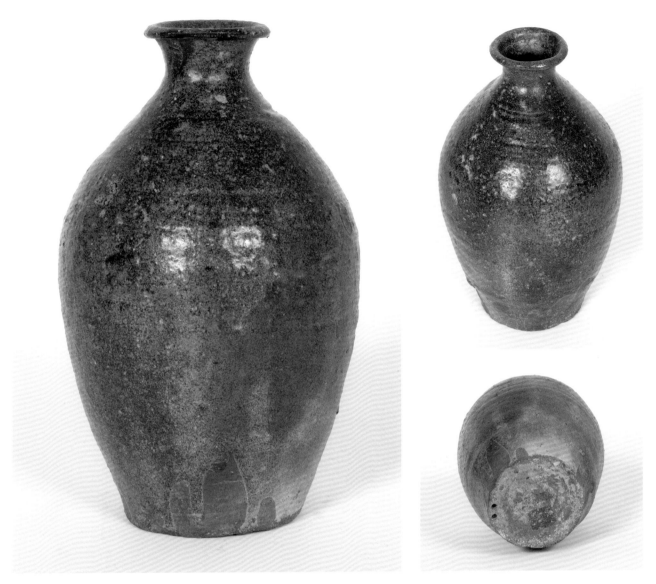

38.
Bottle
12th century, Goryeo
TL results: *fired between 600 & 1,000 years ago*
Stoneware with greenish-brown glaze
H: 23.5 cm, W: 14.2 cm

The mouth of this bottle constricts at the neck before opening out onto slumping shoulders and tapering towards the base. It is coated with a mottled dark olive-colored glaze. When the piece was glazed, it was not completely coated near the base, as evidenced by the dripping glaze near the bottom of the vessel, leaving certain areas of the chocolate-colored surface of the body bare. The slightly concave base is unglazed.

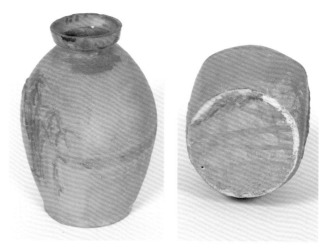

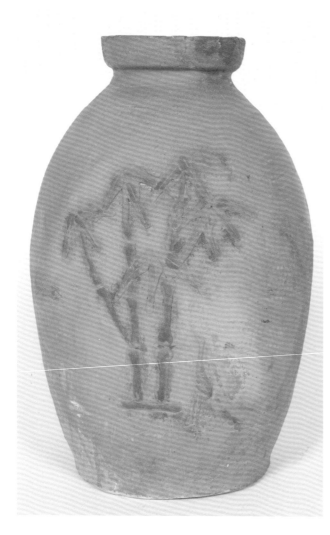

39.
Jar
13th century, Goryeo
TL results: *fired between 600 & 900 years ago*
Stoneware with remnants of celadon glaze
H: 30.4 cm, W: 20.2 cm

With a wide dish-shaped mouth, this jar is shaped like an inverted egg and has a concave base. Two opposing sides of the body have been flattened and applied with a raised-relief design of a tall patch of bamboo under which a crane stands, peering upwards. The celadon glaze on this jar is severely degraded. There are concentric "U"-shaped impressions inside the jar and lines of small rectangular impressions on the outside.

The applied low-relief design on this jar is highly unusual. With the exception of ceramics that may be considered sculptural, Goryeo celadons were usually decorated by incising, shallow carving, molding, inlaying, or painting. The composition of a large floral or vegetal motif taking up the central longitudinal axis with smaller figures, usually cranes, on the ground, began during the twelfth century. Vessels with flattened sides were produced during the thirteenth century (compare with cat. 42).

The degraded celadon glaze is likely the effect of burial as well as less than ideal firing conditions that prevented the glaze from fusing with the body. Although there are potting rings around the outside of the bottle, the concentric "U"-shaped impressions on the inside, and lines of small square impressions on the outside, suggest the form was shaped partly through striking the walls of the jar with a wooden cord-wrapped paddle and wood anvil.

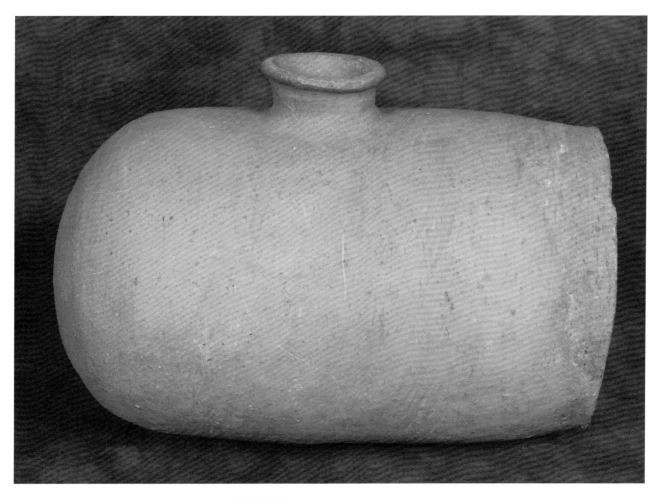

40.
***Janggun* bottle**
11th–14th century, Goryeo
TL results: *fired between 600 & 1,000 years ago*
Unglazed stoneware
H: 18.4 cm, W: 25.3 cm

Called a *janggun* in Korean, one end of this rice bale or co-coon-shaped bottle is flat and the other end is rounded. A trumpet-shaped mouth protrudes from the middle of the oblong vessel. The gray stoneware body has cord impressions throughout and is unglazed.

This bottle would have been potted and fired on its flat surface. As this vessel cannot stand up on its own when resting horizontally, it would have been stabilized with a simple stand such as a ring-like cushion made from straw or a support made from stacked pieces of wood. It may have been placed vertically, on the flat end, when empty. This type of bottle held consumable liquids such as alcohol and had been used in China since the Warring States period (475–221 BC). In Korea, it appeared during the Three Kingdoms period (57 BC–668 AD) and the shape was popular among *buncheong* wares of all types during the fifteenth and sixteenth centuries (see cats. 44 and 47 for a description of the different types of *buncheong* wares). It continued to be used on the peninsula into modern times, far outliving its use in China.

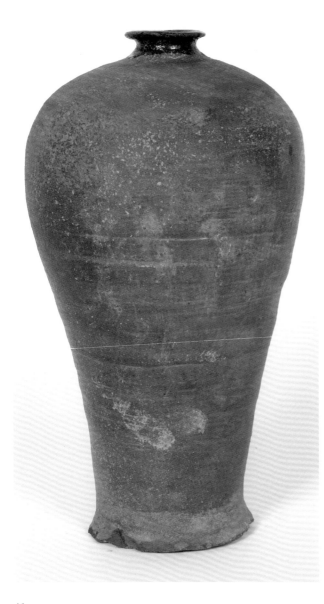

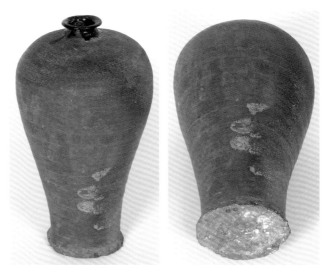

41.
Bottle
13th–14th century, Goryeo
TL results: *fired between 800 & 1,300 years ago*
Stoneware, possibly with glaze
H: 30 cm, W: 17.5 cm

This "plum bottle" (Kr: *maebyeong*, Ch: *méipíng*) has a dark gray body with a small, trumpet mouth and broad, gently sloping shoulders that taper down to a narrow waist, ending with a flaring foot and flat base. Only the mouth is coated with glaze. Potting rings are visible along the sides, and finger imprints can be seen on the lower section of the bottle.

Maebyeong were adopted from Chinese prototypes during the twelfth century and were used to store plumb or ginseng wine. Though often lost, celadon examples originally had associated lids. If unglazed stoneware examples never had lids, they may have been plugged with a wood or cloth stopper to protect the contents. Most Goryeo examples of *maebyeong* have a dish-shaped mouth. The glazed and trumpeted mouth makes this a very uncommon design, though a similarly shaped fourteenth-century Chinese porcelain *méipíng* is in the collection of the Nanjing Museum.[1] There are no tell-tale signs of restoration of the mouth under close visual scrutiny, but previous repair work cannot be discounted without more scientific means of examination. The finger imprints were caused by someone handling the bottle before it was fired.

1 Huping Xu, *The Treasures of the Nanjing Museum* (Hong Kong: London Editions, 2001), 57.

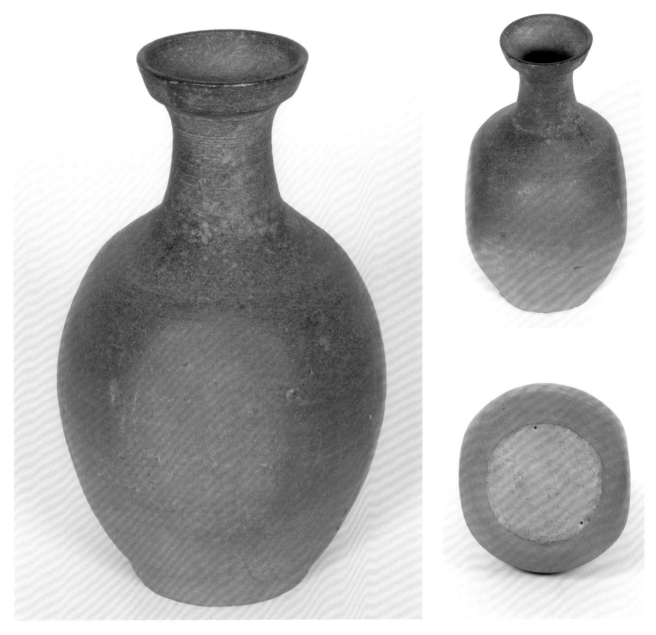

42.
Bottle
13th century, Goryeo
TL results: *fired between 600 & 1,000 years ago*
Unglazed stoneware
H: 25.5 cm, W: 15.7 cm

Of unglazed, gray-bodied stoneware, this bottle has a dish-shaped mouth attached to a neck that opens into a bulbous body and flat base. Two opposing sides of the bottle have been gently flattened, as was fashionable in thirteenth-century vessel forms (compare with cat. 39).

JOSEON DYNASTY (1392–1910)

Founded in 1392 by Yi Seonggye (1335–1408), known as King Taejo (r. 1392–98), the Joseon dynasty would become one of the longest in world history. The rulers of this period were inspired by the idea of creating a society and government based on the principles of Neo-Confucianism. These included a moral code of behavior emphasizing respect and reverence of subjects to rulers, wives to husbands, and children toward parents. Equally, the seniors of the relationships had duties of benevolence and concern toward the juniors.

As in previous periods of Korean history, a strict hierarchical, segregated society existed where rank and status were of utmost importance, but the values and philosophies of Neo-Confucianism would provide the major basis for structure, stability, and unity throughout. An elite class known as the *yangban* consisted of civil and military officials. Commoners made up the majority of the population and consisted mainly of farmers, and below them in status were slaves.

The fifteenth and sixteenth centuries saw a significant period of cultural growth for Korea with new styles and forms of art, while continuing to incorporate and adapt ideas from China. With the establishment of the Joseon dynasty, the heavy influence of the Buddhist church was curbed. King Sejong (r. 1418–1450) was one of the most important rulers in Korean history and helped cultivate advancements in arts and sciences. He established the Hall of Worthies, an institution of scholars that would create the Korean alphabet, *hanguel*, which is used by Koreans today.

The Joseon ceramics featured in this catalogue include porcelains, *buncheong* ware, *onggi* ware and other stonewares. The simple, plain white porcelain produced during the Joseon dynasty, which may have been spurred by imported high quality white wares from China, reached peak production during the eighteenth century. The undecorated surface of these white wares symbolized the Neo-Confucianism virtues of humbleness, purity, and frugality—ideals that defined *yangban* culture. Ceremonial porcelain dishes and incense burners were used for honoring ancestors, an important ritual and duty for families.

Porcelains with cobalt decoration were used for a variety of purposes. The aesthetic taste for blue and white porcelain in Korea came from China, where cobalt was used for blue pigment on ceramics, first employed during the ninth century and then regularly starting in the fourteenth century onwards. The cobalt initially came from mines in Iran, or in the vicinity of, and may have been used as a pigment on Middle Eastern ceramics before it was adopted in China. According to the 1591 publication of *Shiwu Ganzhu* by Huang Yizheng, the price of imported cobalt in China was double that of gold.[1] In Korea, blue and white porcelain began in the mid-fifteenth century. Although cobalt did exist in Korea, the quality was deemed inferior, so the ore was imported from China.[2] As the price of the precious

1 G. St. G. M. Gompertz, *Korean Pottery and Porcelain of the Yi Period* (New York: Frederick A. Praeger, 1968), 54.

2 Ibid., 55.

material was already very expensive by the time it reached China from the Middle East, Korean blue and white porcelain of the fifteenth and sixteenth centuries would have been prohibitively expensive and was therefore mainly for court use. Domestic Chinese cobalt was discovered and used successfully in China during the Chenghua period (1465–1487) and was probably in regular use by the seventeenth century. Japanese invasions of Korea in the late sixteenth century put the production of blue and white porcelain to a standstill during the seventeenth century. It was not until the eighteenth century that production started again, this time for the consumption of a much wider section of Korean society. Lower quality blue and white wares were made in abundance during the nineteenth century and the once elite ware became relatively affordable. As China was successfully using high quality cobalt mined within its own territory, the material would therefore likely have been much easier and cheaper to import into Korea. Such was the demand that even the less desirable, local Korean cobalt was employed at provincial potteries. [3]

Goryeo celadon evolved into a new form of ceramics known as *buncheong*, a grayish, "powder green" glazed stoneware decorated with white slip and which often features stamped and inlaid decorations. *Buncheong* wares were used by all levels of society, kings and commoners alike. This type of humble yet socially versatile stoneware flourished only in the early part of the dynasty. Japanese invasions, launched by the warlord Toyotomi Hideyoshi, in 1592 and 1598 decimated the production of Korean ceramics. Entire pottery-producing villages were relocated to Japan, where they made significant and lasting contributions to the Japanese ceramics industry. Another reason for the demise of *buncheong* wares was the rising popularity of white porcelain. During the sixteenth century, *buncheong* wares were sometimes entirely coated in white slip in order to imitate porcelain wares (cat. 47). The devastations of war continued to affect Korea in the seventeenth century with Manchu invasions from the north.

The latter part of the Joseon dynasty saw a greater production of porcelains as they became used by the general public, outside of the *yangban* class. The utilitarian *onggi* ware (cats. 107-108), a stoneware with dark brown glaze, was used for everyday purposes and essential to the food culture of Korea throughout all levels of society.

3 Ibid., 67-68.

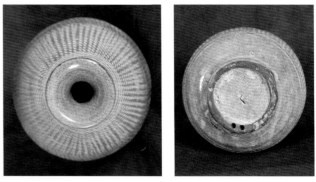

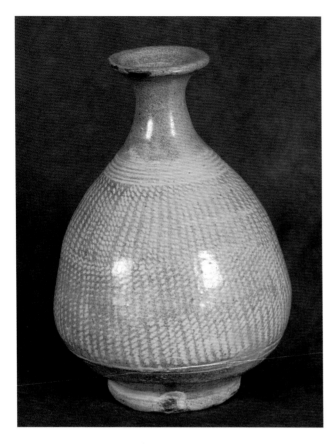

43.
Bottle
15th century, Joseon
TL results: *fired between 400 & 700 years ago*
Stoneware with inlaid designs under *buncheong* glaze
H: 14.4 cm, W: 11.2 cm

Topped with a trumpet-shaped mouth and neck, the form of this bottle opens into drooping shoulders and a sagging body before turning inwards to meet the foot. The decorations are stamped and incised and then inlaid in white under a *buncheong* ("powder green") glaze. A series of inlaid concentric rings just below the neck is followed by closely packed columns of short, cord-like vertical lines (a design often referred to by the Japanese term "rope curtain") that fill up the body of the vessel, ending with two concentric rings near the foot. The footrim is free of glaze and has both oxidized red patches as well as unoxidized gray patches. The areas outside and within the footrim have a thin layer of white slip under the glaze.

Vigorously stamped and inlaid *buncheong* wares, such as this bottle, are early examples of the revival of elite ceramics production during the early Joseon dynasty, after the decline of the industry during the end of the Goryeo dynasty. The dense, repetitive patterns found on many inlaid *buncheong* wares of the fifteenth century are reminiscent of the crowded stamped designs found on gray stoneware vessels of the Unified Silla period (668–935). The surface of the body material seen on the footrim of this vessel has oxidized to a reddish color during firing. The gray areas are where clay pads were stuck so that the bottle could be lifted off of the firing surface in the kiln without the glaze sticking to the surface. The areas covered by the clay pads would have been prevented from oxidizing, therefore remaining a gray color.

The collector's father used this bottle for pouring alcohol.

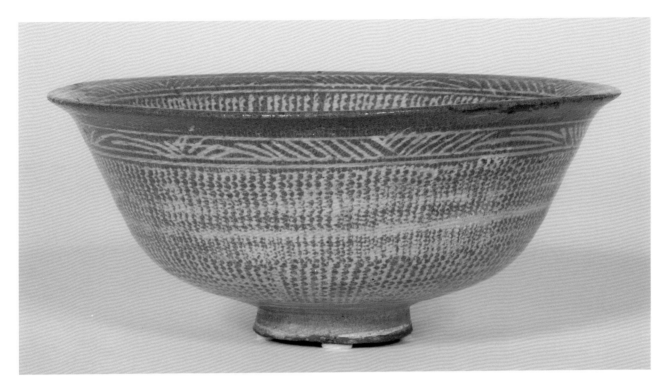

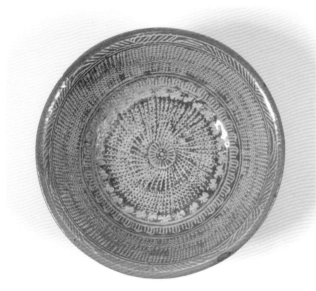

44.
Bowl
15th century, Joseon
TL results: *fired between 400 & 700 years ago*
Stoneware with inlaid designs under *buncheong* glaze
H: 8.3 cm, W: 19.3 cm
Courtesy of Daewon Kwon and Chong J. Kwon

This bowl is stamped, carved, and inlaid with designs under *buncheong* glaze. The inner lip is banded with a register of what may be stylized grasses. Below that, tightly packed, vertical cord-like designs predominate the bowl, followed by registers of lotus petals, butterflies or moths, another wide band of the cord-like pattern, and finally a chrysanthemum flower in the center. The outside surface of the bowl is undecorated at the lip, under which is a band of stylized grasses followed by more of the cord design that extends to just above where the foot starts. The base within the footrim has impressions of several hastily stamped chrysanthemum designs and a thin coat of white slip.

Buncheong wares were the successors of inlaid Goryeo celadons. They were produced during the first two centuries of the Joseon dynasty. The term, *buncheong*, meaning "powder green," refers to the grayish-green tinted glaze. The wares were decorated under the glaze by inlaying with white slip into depressions that were either incised or stamped. White slip could also be brushed onto the body (see cat. 47). Examples made during the transition from inlaid celadon to *buncheong* continued to employ black inlay, but the sole use of white slip became the norm by the second half of the fifteenth century.

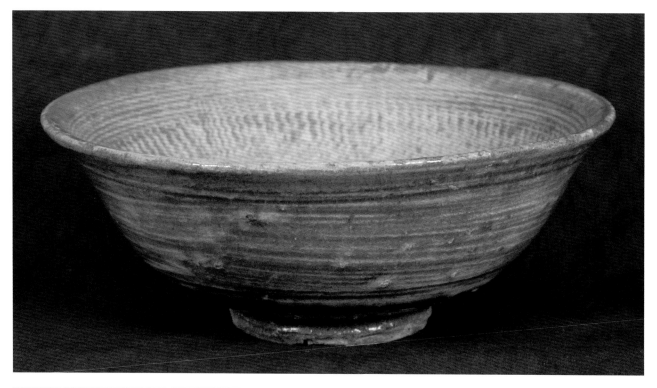

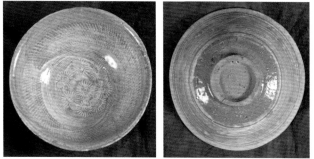

45.
Bowl
15th century, Joseon
TL results: *fired between 400 & 700 years ago*
Stoneware with inlaid designs under *buncheong* glaze
H: 6.9 cm, W: 18 cm

This bowl with flared lip is decorated with a central field consisting of eight stamped chrysanthemum flowers followed by a register of concentric rings, and a wide band of the rope curtain pattern, ending with another register of concentric rings near the lip. The outside of the bowl is simply brushed with slip, ending about two-thirds of the way down, leaving the area above the foot unslipped. The base and footrim are unglazed. The inside of the bowl appears to have been lightly brushed with slip again after the inlaying process was already completed, possibly after the brush was almost dry from coating the outside of the bowl. Five scars caused by clay firing pads are visible inside the bowl.

This bowl has designs typical of fifteenth-century *buncheong* wares. The scars inside this bowl indicate it was fired in a stack with other bowls resting inside one another, separated by clay pads on the footrims. Although this left more scars on the finished product, a greater number of vessels could be fired at one time than if individual ceramics were placed inside protective saggars during firing. Saggars are ceramic containers used to protect pottery from flame, smoke, and flying debris inside the kiln.

Buncheong ware tea bowls were held in high esteem by Japanese tea masters by the middle of the sixteenth century. There was even a kiln producing *buncheong* wares and coarse white porcelain in Busan (Pusan), operated by the Japanese between 1639 and 1737, which made ceramics according to Japanese specifications.[1]

1 Ikutaro Itoh, "Korean Ceramics of the Koryŏ and Chosŏn Dynasties," in *Korean Ceramics from the Museum of Oriental Ceramics*, Osaka, ed. Judith G. Smith (New York: The Metropolitan Museum of Art, 2000), 28-29.

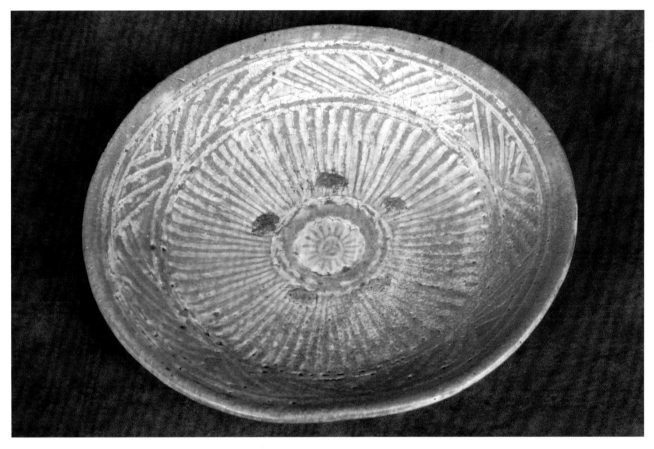

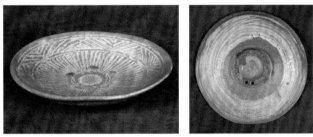

This dish is carved, stamped, and inlaid with decorations under *buncheong* glaze. A band of repeating "V"-shaped patterns appears just below the lip. A wide register of radiating lines follow, encircling another thin, undecorated band with a stamped chrysanthemum flower in the center. Five spur marks surround the central medallion. The outside of the bowl is brushed with white slip. The base inside the foot-rim is glazed.

Like cat. 45, this dish was fired in a stack along with other dishes, separated with clay pads. The collector's parents and grandparents used this dish for serving diced radish kimchi (Kr: *kkakdugi*).

46.
Dish
15th century, Joseon
TL results: *fired between 300 & 600 years ago*
Stoneware with inlaid designs under *buncheong* glaze
H: 3.4 cm, W: 15.7 cm

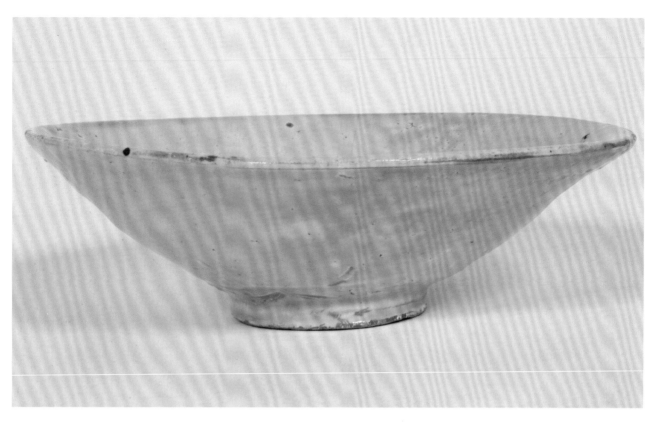

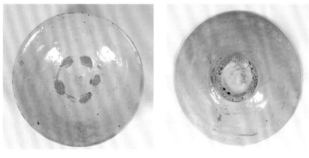

47.
Dish
16th century, Joseon
TL results: *fired between 400 & 700 years ago*
Stoneware coated in white slip under *buncheong* glaze
H: 5.2 cm, W: 15.9 cm

This dish is nearly completely coated in white slip under *buncheong* glaze, including the base within the footrim. Greenish tinges in the glaze are apparent where the "powder-green" glaze has pooled. A few gaps in the slip on the outer wall of the vessel reveal the grayish color characteristic of *buncheong* wares where the slip has been carved away. The center of the dish has five kiln scars where clay pads were placed directly on top of the dish so that another could be fired on top in a stacked fashion. A round arch from the footrim of the dish fired above this dish can also be seen. The footrim has adhesions of kiln grit.

Due to the preference for white porcelain starting in the fifteenth century, *buncheong* wares were being dipped in white slip to imitate the more prestigious material by the sixteenth century. The slip could either be left plain, some with a thick coat to imitate white porcelain, as in this example, or decorated by incising or scraping away the surface to reveal the darker body material underneath.

The collector recalls this dish being used in his family to serve food on special occasions, such as birthdays.

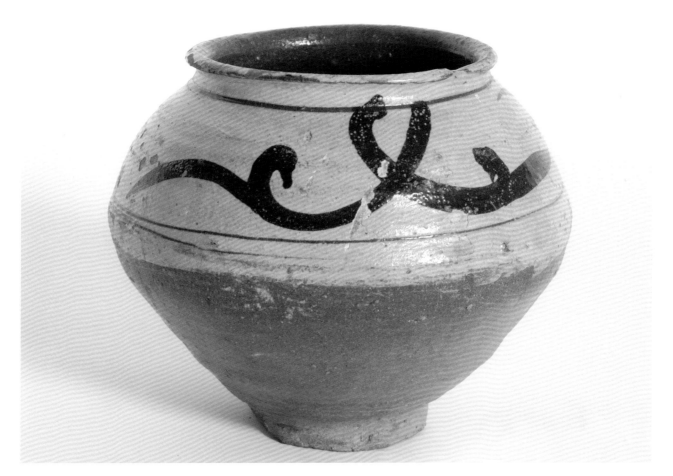

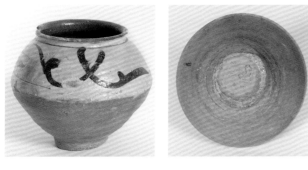

48.
Jar
Second half of 15th–first half of 16th century, Joseon
Stoneware with slip and iron oxide decoration under
buncheong glaze
H: 12.8 cm, W: 14.5 cm

With a profile similar to two bowls joined to each other at the mouths, the top half of this jar is coated in a cream-colored slip that has been brushed on. Two lateral running lines have been incised into the slip so that the dark-colored body material shows through—one just below the lip and the other just above the middle of the jar. A stylized vegetal scroll was painted, in iron oxide, on either side of the vessel, between these lines. The jar was then coated in a thin layer of *buncheong*, or "powder green" glaze. A star-like design was impressed into the base in order to compact the clay to prevent it from cracking during the firing process.

This type of *buncheong* ware, with iron oxide decoration painted over a slipped ground, was made in kilns near Mount Gyeryong in South Chungcheong Province, located in the western part of present-day South Korea. These kilns may have originally been set up by Buddhist monks in order to make up some of the income that was lost when the Joseon dynasty came to power and Buddhism lost official favor to Confucianism philosophy.[1] Wares produced in these kilns were made for utilitarian purposes and often show signs of careless potting and decoration, which gives the wares an individualistic, rustic feel. However, vessels made in these same kilns with more complicated decoration, often portraying fish, can be executed with much skill—demonstrating the fluid competence of the painter.

1 G. St. G. M. Gompertz, *Korean Pottery and Porcelain of the Yi Period* (New York: Frederick A. Praeger, 1968), 34.

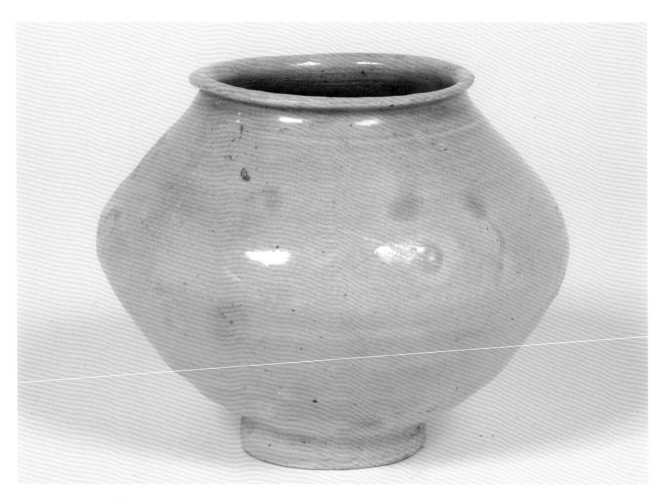

49.
Jar
Second half of 15th–16th century, Joseon
TL results: *fired between 400 & 700 years ago*
Porcelain
H: 14 cm, W: 16.5 cm

The same form of jar as cats. 48, 103, and 104, this vessel is made of porcelain coated in a clear glaze with a bluish-green tint. Like cats. 48 and 103, this jar may also have been made at kilns near Mount Gyeryong in South Chungcheong Province, where shards of porcelain have been discovered along with black wares and *buncheong* wares coated in white slip and painted with iron oxide.[1]

The production of porcelain in Korea came to maturity by the reign of King Sejong (1418–50). A contemporary fifteenth-century source states that porcelain was used exclusively by the royal household at this time.[2] Before this, most of the porcelain used in Korea was imported from China. In 1466, in the reign of King Sejo (1455–68), an order was given stating porcelain was to be produced only by order of the royal household.[3] However, this injunction is unlikely to have lasted much longer than Sejo's reign. As this jar is probably not of sufficient quality for royal use, it was mostly likely made after the porcelain prohibition of 1466 but before the end of production at the Mount Gyeryong kilns in the late sixteenth century.

1 G. St. G. M. Gompertz, *Korean Pottery and Porcelain of the Yi Period* (New York: Frederick A. Praeger, 1968), 71.
2 Ibid., 15-16.
3 Ibid., 44-45.

50.
Bottle
15th–16th century, Joseon
TL results: *fired between 350 & 600 years ago*
Porcelain
H: 22.3 cm, W: 13.4 cm

Modeled after Chinese *yùhúchūn* bottles, this white porcelain (Kr: *baekja*) container has a trumpeted mouth that opens into a pear-shaped body, resting on top of a foot. The base inside the footrim is glazed. The footrim itself is unglazed and has adhesions of kiln grit.

The *yangban* ruling class of the Joseon dynasty distanced themselves from the lavishness of state-sponsored Buddhism of the Goryeo dynasty. Instead, they turned to Neo-Confucianism, which emphasized proper social order and relationships through modesty, simplicity, and purity. These values are reflected in the preference for white wares, especially porcelain, during the Joseon dynasty. The import of "sweet white" (Ch: *tiánbái*) as well as blue and white porcelain from China in the fifteenth century probably ignited the Korean taste for these types of wares. This bottle was used for holding wine.

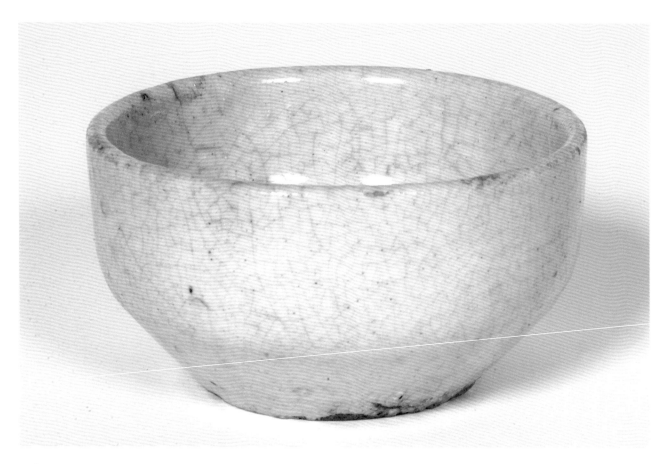

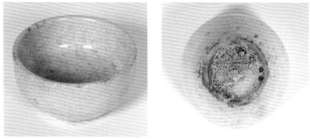

51.
Cup
17th–18th century, Joseon
TL results: *fired between 200 & 400 years ago*
Porcelain
H: 4.2 cm, W: 8 cm

This simple cup is coated in a finely crackled clear glaze. The upper two-thirds of the vessel has straight sides and then turns gently inwards towards the foot. The thick base is undercut and has adhesions of kiln grit. The exposed body material of the footrim has oxidized to an orangish color during the firing process. The footrim has been ground smooth, probably to counteract the adhesions of rough and uneven kiln grit.

If existing examples are any indication, cups were not common during the Joseon dynasty as most drinking was done from bowls. It may have been more common to drink alcohol from small cups such as this.

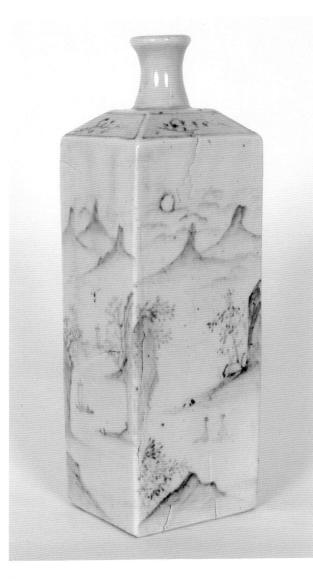

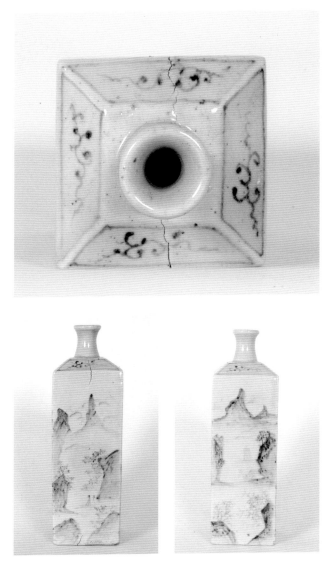

52.
Bottle
18th century, Joseon
TL results: *fired between 100 & 200 years ago*
Porcelain with underglaze cobalt decoration
H: 21.7 cm, W: 6.9 cm

Decorated with landscape scenes in underglaze cobalt, this four-sided bottle has a trumpet-shaped mouth and neck on top of a flat shoulder that then slants down diagonally and angles again into vertical sides. The slanted shoulders are decorated with four outlined panels with tendrils depicted in each. The sides are painted with traditional "mountains and water" (Kr: *sansu*, Ch: *shān shuǐ*) landscape scenes. Boats with sails are depicted floating in water among trees and mountains under a moonlit sky. Although there are no painted borders, the scene on each side is independent of the side next to it. The base is flat and free of glaze.

The underglaze decoration on this bottle was applied with cobalt and intended to turn blue during the firing process. However, it has turned out a grayish color here due to misfiring in the kiln. This bottle was used for holding wine and would likely have been owned by a Confucian scholar familiar with Chinese painting genres. The collector's father had used this as a wine bottle.

53.
Rice scoop
19th–20th century, Joseon–Modern
Porcelain
L: 19.8 cm, W: 7 cm (spoon mouth)

The white porcelain body of this rice scoop is covered with a blue-tinted clear glaze. A ginseng plant decoration was molded onto the handle. The two stems and attached flowers of the plant grow around either side of the hole on top of the handle. The actual paddle-like scoop portion is slightly concave on the front side.

Rice scoops were used to serve cooked rice from a communal container into individual bowls. A cord would have been strung through the hole in the handle, so it could be hung when not in use. The collector recalls his mother using this scoop when entertaining guests. When serving the rice, she would keep a bowl of cold water nearby, into which to dip the scoop. The cold water would keep the cooked rice from sticking to the surface of the porcelain scoop, which is a constant bother when using scoops made from bamboo or wood.

Asian ginseng (*Panax schinseng*) (Kr: *insam*, Ch: *rénshēn*) is an important plant in East Asian medicinal culture, where it is used as a panacea and aphrodisiac. The first mention of ginseng in Korea was a gift to the Silla king in 795.[1] The name of the plant can be translated as "man root." This is because the thick, forked roots of the plant often resemble a human with a head, torso, arms, and legs.

1 Keith Pratt and Richard Rutt, *Korea: A Historical and Cultural Dictionary* (Richmond: Curzon, 1996), 144.

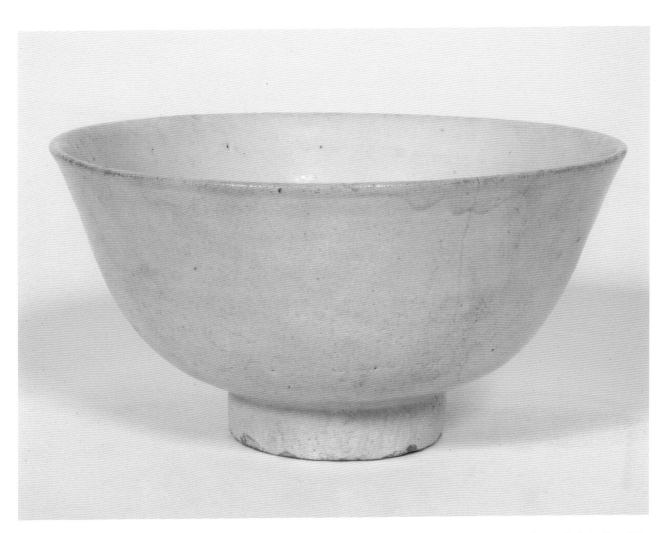

This bowl, probably used for rice, has a slightly flared lip and is undecorated. There are nine scars left by clay pads on the inside of the bowl and ten on the footrim. Except for the areas where the clay pads were placed, the bowl is completely coated in a clear glaze.

The large number of scars, left by clay pads when they were pulled off the vessel after firing, indicate this bowl was made in the southern part of Korea. The collector recalls that his family would place pomegranates in this bowl and used it as a decorative piece, as well as a bowl for rice.

54.
Bowl
19th century, Joseon
TL results: *fired between 150 & 250 years ago*
Porcelain
H: 9.7 cm, W: 18.7 cm

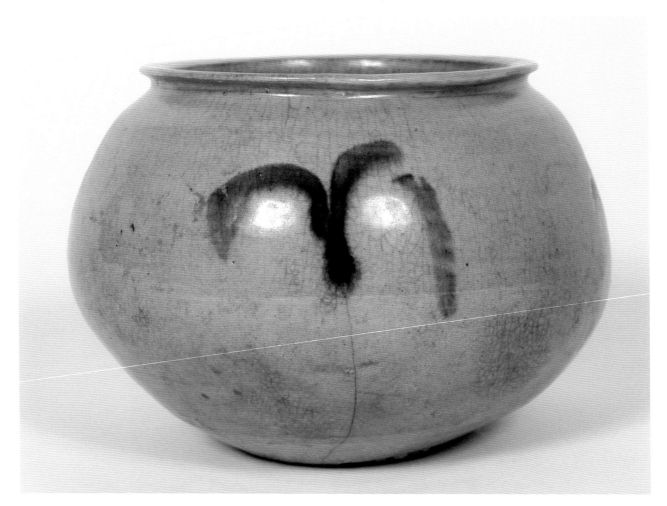

Heavily potted, especially at the base, this jar has a thin, pronounced lip that opens into a wide, squat, unevenly globular body. On opposing sides are painted simple abstract plant (probably orchid) designs in iron oxide, each executed with two seemingly spontaneous brush strokes. The finely crackled glaze has a bluish tone. Faint and low-cut, the foot and base are obscured by glaze and adhesions of coarse kiln grit. The areas not coated in glaze, mainly on the inside, near the mouth of the jar, have oxidized to a reddish color during the firing process.

Orchids are a symbol for spring adopted from China. This utilitarian jar would have contained foodstuffs such as sauces. The well-grooved lip was probably designed so that a thick paper cover could be tied in place, protecting the contents of the jar.

55.
Jar
17th–18th century, Joseon
Porcelain with underglaze iron oxide decoration
H: 13.5 cm, W: 18.5 cm

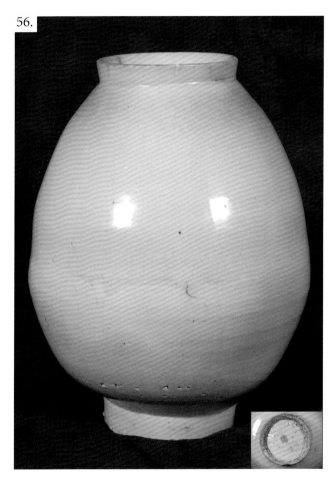

56.

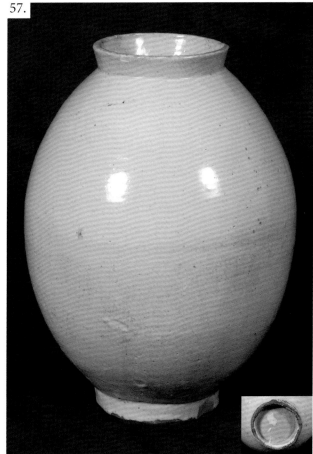

57.

56.
Storage jar
Second half of 18th–19th century, Joseon
TL results: *fired between 150 & 300 years ago*
Porcelain
H: 36 cm, W: 28.3 cm

57.
Storage jar
Second half of 18th–19th century, Joseon
TL results: *fired between 200 & 400 years ago*
Porcelain
H: 36.8 cm, W: 27.5 cm

Made from white porcelain (Kr: *baekja*), these two jars were made with varying degrees of precision. The bodies are egg-shaped with mouths that flare outwards and footrims that are wiped free of glaze. The base of cat. 56 is coated with glaze, whereas the base of cat. 57 only has, seemingly, accidental splotches of glaze. The body material, where it has not been covered by glaze, has oxidized to an orangish color during firing. Each jar was made with a separate upper half and lower half and then luted together. Little attention was paid to hide the inconsistency of the two halves on cat. 56, whereas there was an attempt to create more cohesive forms for cat. 57.

These types of white spherical or oblong jars were made in large numbers during the middle of the Joseon period. Seventeenth-century examples, commonly called "moon jars," tend to be more spherical in form and often have just a lip without a neck at the mouth of the jar, whereas later examples have a more elongated shape and a short neck.

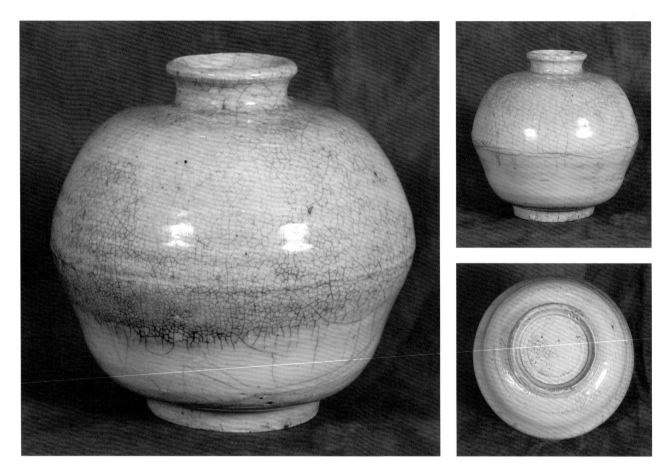

58.
Jar
18th–19th century, Joseon
TL results: *fired between 150 & 250 years ago*
Porcelain
H: 18.5 cm, W: 19.8 cm

This plain jar is coated in a clear glaze that has a network of fine crackles throughout the top three quarters of the body. It is heavily potted and, like cats. 56 and 57, made by joining the upper half and the lower half, using liquid clay as an adhesive, before firing—a process called luting. The lip rests on a short, constricted neck that opens up into an uneven, globular body. The footrim is free of glaze, and the base is glazed.

Crackles, networks of small cracks in the glaze, are caused by the quick cooling of the kiln after firing. The glaze shrinks faster than the body, which causes stress in the glaze and causes it to crack. This feature, which can be induced, is usually accidental in ceramics made in Korean kilns. The dark brown color of the crackles on this jar was caused by staining from use.

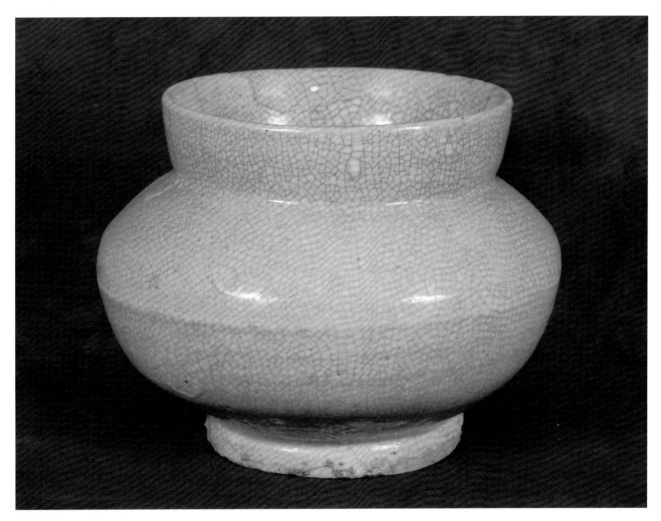

With a relatively large mouth and slightly flaring neck, this thickly potted jar has a finely crackled glaze (see cat. 58 for a description of how crackles occur). The base is covered in the same crackled glaze and the footrim, with some kiln grit adhering, was wiped free of glaze before firing.

59.
Jar
19th century, Joseon
TL results: *fired between 150 & 250 years ago*
Porcelain
H: 13 cm, W: 16.4 cm

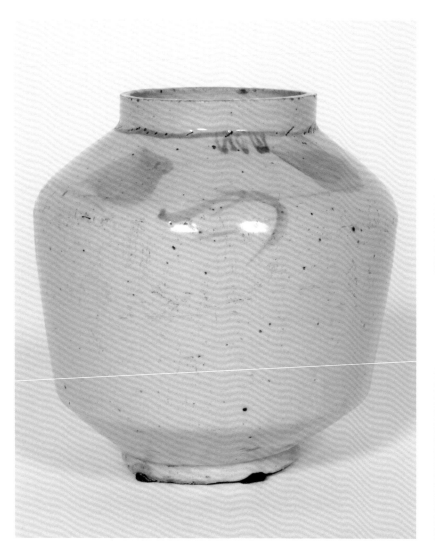

60.
Jar
19th century, Joseon
TL results: *fired between 200 & 400 years ago*
Porcelain with underglaze cobalt decoration
H: 14.2 cm, W: 13.2 cm
Courtesy of Daewon Kwon and Chong J. Kwon

The shoulder of this straight-necked jar slants down verti-cally before rounding into a straight, tapered body that angles inwards before reaching the foot. The footrim and base are glazed, with larger pieces of kiln grit adhering to the base. Four patches of cobalt wash are painted equidistant from each other on the shoulder, enclosed by lines—one just below the neck and one about two-thirds of the way down the shoulder. Two sets of three small, petal-like motifs are painted below the neck on opposite sides (a similar petal-like motif can be seen on the jar in cat. 65). The glaze has a bluish tint.

The shape of this jar is reminiscent of brown glazed jars used to store honey or condiments, the difference being that the brown glazed jars have faceted sides.[1]

1 For an example of such a jar, see: Yong-i Yun, "Part III Punchŏng Wares and Porcelains of the Chosŏn Dynasty," in *Korean Art from the Gompertz and Other Collections in the Fitzwilliam Museum: A Complete Catalogue*, ed. Regina Krahl (Cambridge: Cambridge University Press, 2006), 303.

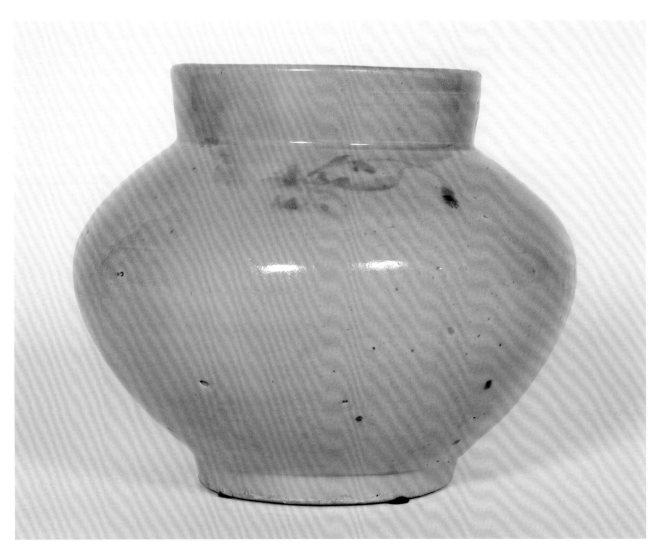

The relatively high neck of this jar suggests a nineteenth-century date. Three floral motifs, possibly orchids, are painted in a delicate light blue, equidistant from each other on the shoulder of the squat, globular jar. The base is glazed and has adhesions of sand. The footrim is free of glaze. A ring of kiln grit can be seen inside the well of this jar.

The adhesions of sand seen inside this jar indicate there was another smaller piece of ceramic placed into this vessel when it was fired in order to make the best use of space. This jar would have functioned to store condiments or other foodstuffs.

61.
Jar
19th century, Joseon
TL results: *fired between 200 & 400 years ago*
Porcelain with underglaze cobalt decoration
H: 18.7 cm, W: 23.4 cm
Courtesy of Daewon Kwon and Chong J. Kwon

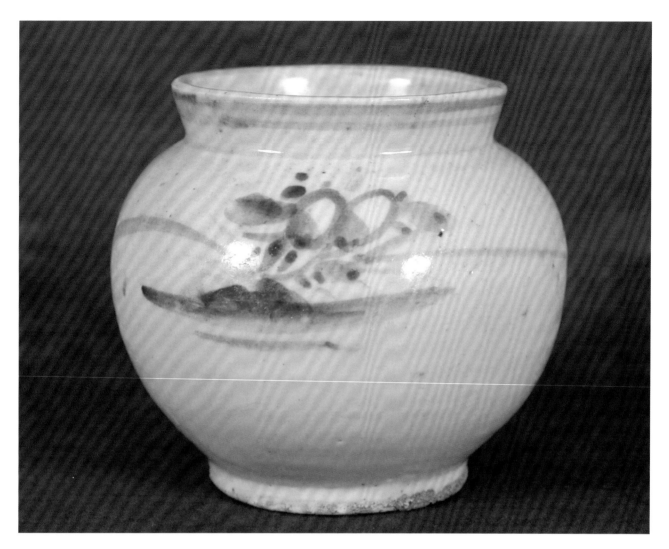

Painted in cobalt blue on opposite sides of this jar are orchids. The short neck flares slightly above a spherical body. The base is glazed, but the foot is unglazed and has adhesions of kiln grit.

The angle of the neck probably facilitated the securing of a cloth or paper cover with a cord.

62.
Jar
19th–early 20th century, Joseon
Porcelain with underglaze cobalt decoration
H: 9.6 cm, W: 11.1 cm

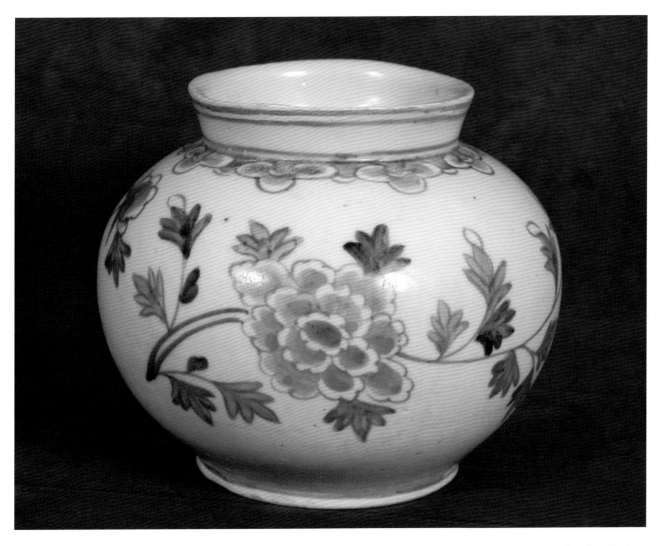

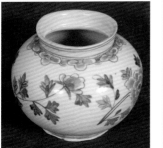

63.
Jar
19th–early 20th century, Joseon
TL results: *fired between 100 & 200 years ago*
Porcelain with underglaze cobalt decoration
H: 13.7 cm, W: 16.4 cm

This globular jar has a slightly flaring neck. A band of *yeo ui* (Ch: *rúyì*) designs are painted on the shoulders just below the neck. The main body is decorated with sprays of peony flowers. The designs are outlined in a darker shade of blue and filled in with a lighter blue wash. The footrim is unglazed, but the base is glazed.

The peonies painted on this jar and the condiment containers in cat. 64 symbolize wealth and nobility. The flower was cultivated in the Chinese Tang dynasty (618–907) capitals of Chang'an and Luoyang, particularly during the seventh and early eighth centuries. Since then, the peony has been an auspicious symbol and eventually spread into the repertoire of Korean motifs.

This jar is a product of the Bunwon kilns, which were set up as the official kilns during the late fifteenth century. They are located in present-day Gwangju district, southeast of Seoul. These types of storage jars were originally used to hold sauces or other food consumables. In the 1950s, the collector's family used this jar as a flower pot.

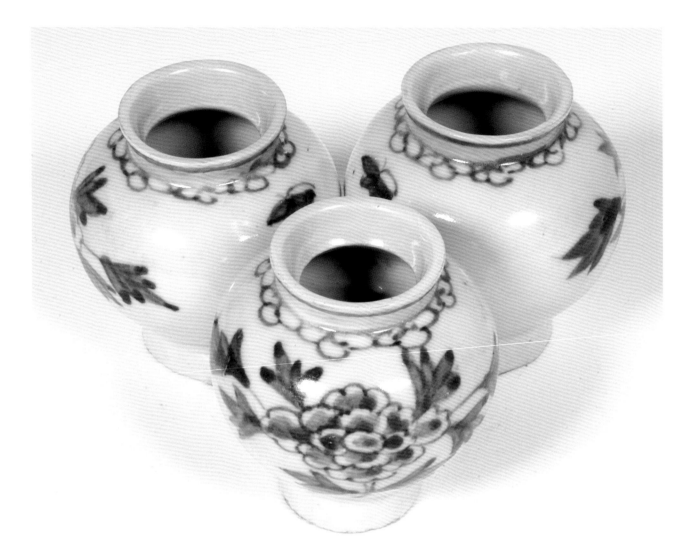

64.
Condiment containers
19th–early 20th century, Joseon
TL results: *fired between 150 & 250 years ago*
Porcelain with underglaze cobalt decoration
H: 7.8 cm, W: 14.7 cm

Shaped like miniature versions of cat. 63, these three condiment containers are luted to a three-ended base. Each has a flaring neck on a spherical body. A line is painted around the lips, and a *yeo ui* (Ch: *rúyì*) collar surrounds the shoulders where they meet the necks. A peony is painted on the front of each jar and a butterfly on each back. The bottom of the base is free of the blue-tined glaze and has partly oxidized to an orangish color during firing.

Such sets of jars were used to hold condiments or spices. Each of the jars would have originally had a lid with a nipple-shaped knob, which are now lost.[1] This condiment set is probably the product of the Bunwon kilns. The containers were regularly used in the collector's household for holding spices during cooking.

1 For an example that is still associated with its lids, see: Pierre Cambon, *L' Art coréen au musée Guimet. Réunion des Musées Nationaux* (Paris: Réunion des Musées Nationaux, 2001), 122.

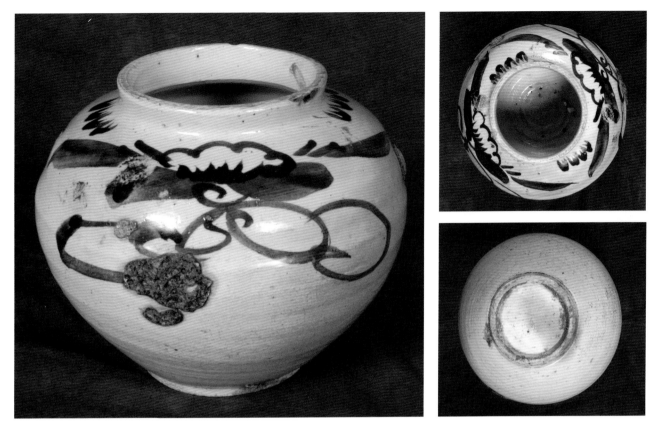

65.
Jar
Late 19th–early 20th century, Joseon
TL results: *fired between 150 & 250 years ago*
Porcelain with underglaze cobalt decoration
H: 14.5 cm, W: 16.5 cm

This short-necked jar has a bulbous body that tapers towards the foot. It is painted on the top half, in dark blue cobalt, with two bold floral motifs, probably peonies, with wide spreading leaves that join the two motifs at the sides. The base is glazed and has adhesions of kiln grit where it meets the foot. Both the footrim and lip of the jar have been wiped free of glaze before firing. A few firing scars are located on the side of the jar.

The blue pigment on this jar is darker than what one would usually expect. The Bunwon kilns, the official kilns of the Joseon dynasty, lost royal support in 1883, and the potteries continued exclusively in a private capacity. Japanese potters were invited to work at the kilns and introduced technology that was not used before in Korea, such as transfer printing.[1] Judging by the rough quality of this jar, it was probably made at a provincial kiln rather than the Bunwon kilns. However, provincial potters may have used imported material or technology that was being introduced from Japan in producing the unusual blue pigment on this jar.

The fact that the decoration is painted only on the upper half of the jar suggests that it was meant to be placed in a low position—where the decoration can be fully seen from above. The unglazed lip indicates this jar probably originally had a lid. The firing scars on the jar show where another object was in contact with the vessel during firing and had to be pulled off after cooling.

1 G. St. G. M. Gompertz, *Korean Pottery and Porcelain of the Yi Period* (New York: Frederick A. Praeger, 1968), 67.

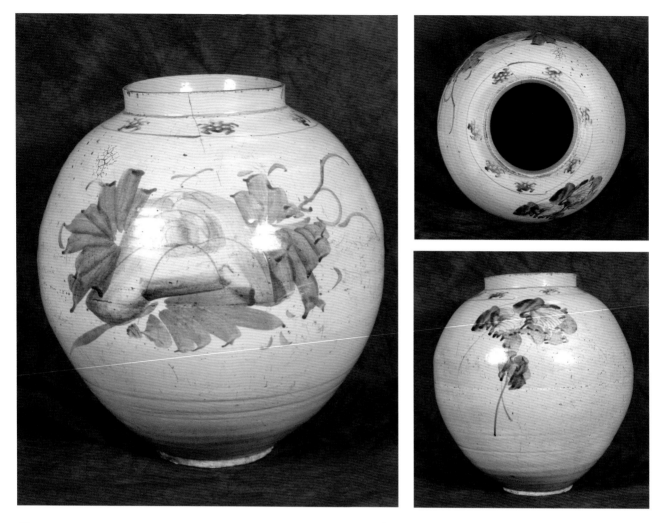

66.
Jar
19th century, Joseon
TL results: *fired between 150 & 300 years ago*
Porcelain with underglaze cobalt decoration
H: 40 cm, W: 36.5 cm

With a short and straight neck, this large, globular jar rests on a relatively small foot. It was made in two parts (top and bottom) and luted together at the center. The lip shows evidence of being ground or smoothed down after firing. The area just below the neck is decorated with a band of seven stamped abstract turtle-like designs. The main decoration on the front of the body is composed of a large abstract flower with leaves, painted in bold brush strokes, and a few tendrils. The back is decorated with a smaller but similar composition. The base is glazed, and the footrim had been haphazardly wiped free of glaze.

Judging by the boldly painted brush strokes, this jar was made at a kiln in Haeju City, South Hwanghae Province, located in present-day North Korea. These types of storage jars held foodstuffs and were kept in the women's quarters. The jar probably originally had an associated lid.

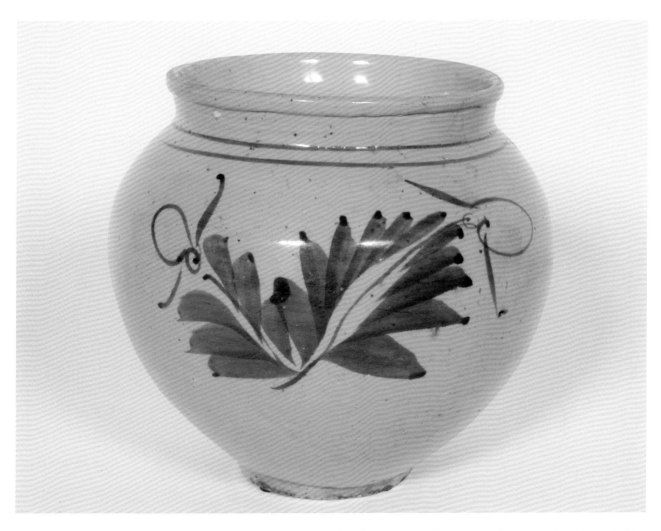

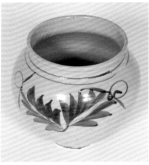

67.
Jar
19th century, Joseon
TL results: *fired between 150 & 300 years ago*
Porcelain with underglaze cobalt decoration
H: 24.3 cm, W: 26.2 cm
Courtesy of Daewon Kwon and Chong J. Kwon

This storage jar has a protruding lip and wide mouth. The spherical body tapers as it meets the foot. It is decorated with two parallel lines that run around the jar, just below the short neck. The body is painted with an abstract vegetal motif executed mainly with broad brush strokes. The base is glazed, and the footrim appears to have been ground smooth.

This vessel was made at a kiln in Haeju, South Hwanghae Province. Such jars were meant to store foodstuffs and were kept in the women's quarters in a traditional Korean household setting. The protruding lip secured the cord that held in place a cover made of thick paper. The footrim was probably ground down to remove the kiln grit in order to make it stand evenly.

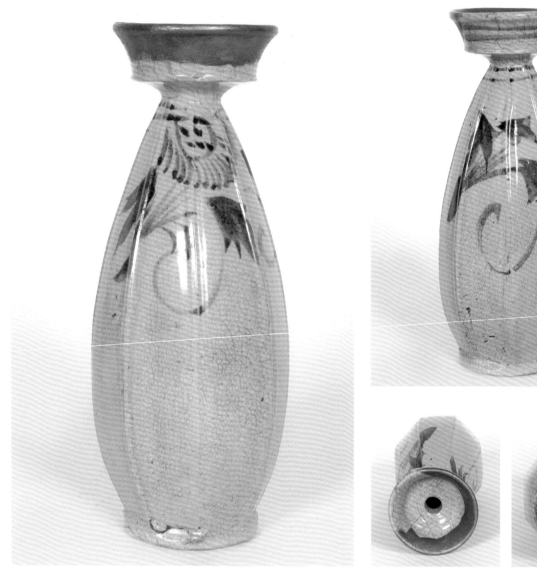

68.
Bottle
19th century, Joseon
TL results: *fired between 150 & 300 years ago*
Porcelain with underglaze cobalt decoration and
gold lacquer repair
H: 31 cm, W: 12.5 cm

The dish-shaped mouth of this bottle constricts at the neck and opens into a body that resembles an elongated, unopened flower bud with vertical ridges. It is painted with floral motifs, including a chrysanthemum flower, on the upper half of the vessel. The base is glazed, and the footrim has adhesions of kiln grit. Much of the mouth has been restored with Japanese gold lacquer (*kintsugi*).

The painting style of the decoration indicates this bottle was made at a kiln in the city of Haeju, located in South Hwanghae Province. This bottle was probably used for storing sesame oil.

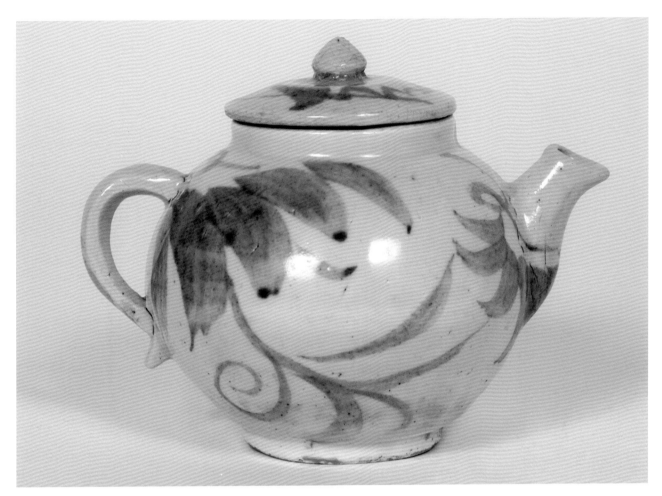

69.
Condiment ewer
19th–20th century, Joseon–Modern
Porcelain with underglaze cobalt decoration
H: 10.3 cm, W: 14.1 cm (with spout and handle)

The globular body of this condiment ewer has a short neck on which sits a lid with a bud-like knob on top. It has a stout spout on one side and a curved, ear-like handle on the other. The body and lid are painted with abstract vegetal designs, with tendrils, in bold brush strokes. The design on the body also runs onto the spout and handle. The footrim is free of the slightly grayish-blue-toned glaze. The base is glazed and has adhesions of kiln grit.

This ewer was used in the collector's family for pouring condiments such as soy sauce or sesame oil. It was designed especially to hold condiments as the small handle renders the design impractical for serving hot drinks. When pouring, the fingers would be in direct contact with the pot, which would be burned if the ewer were hot. The painting style indicates this ewer was made in Haeju, South Hwanghae Province.

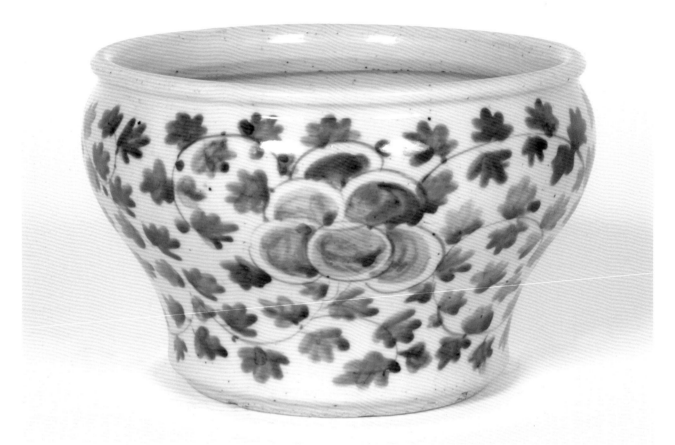

70.
Spittoon
19th century, Joseon
TL results: *fired between 150 & 250 years ago*
Porcelain with underglaze cobalt decoration
H: 12.8 cm, W: 20.3 cm

The upper section of this spittoon is wider than the base and has a well-defined lip. It is painted with peony and vegetal scroll motifs throughout the body. The base is glazed; the recessed footrim is unglazed.

The decoration and shape of this waste receptacle were copied from contemporary Chinese wares. Although a faithful copy of a Chinese design, the painting is applied in a less restricted, Korean fashion with minimal outlines and leaves painted with individual brush strokes. This piece has been passed down from the collector's family. He remembers using this as a chamber pot at night as a young child.

71.
Bottle
18th–19th century, Joseon
TL results: *fired between 250 & 400 years ago*
Porcelain
H: 26.5 cm, W: 17 cm
Courtesy of Daewon Kwon and Chong J. Kwon

This bottle has a long trumpeted neck and mouth on a globular body. It is coated in greenish-tinted glaze, including on the base. The footrim is free of glaze and has oxidized to an orangish color during firing, much of which is covered in kiln grit.

A similarly shaped but slightly taller bottle painted with a dragon in cobalt is held in the ethnology collections of the Smithsonian Institution, Washington, D.C.[1] The original collector, John Baptiste Bernadou (1858–1908), obtained that bottle in Gwangju, Gyeonggi province. In his original field notes, Bernadou states the vessel is a "water bottle." Working with Korean expatriates in Washington, D.C., Dr. Walter Hough (1859–1935) was the first to write a monograph on Bernadou's Korean collection.[2] He writes of the bottle: "Used in buying and selling liquors, but not at the table."[3] It may be that these bottles were used for both alcoholic and nonalcoholic beverages (see entry for cat. 73). However, they were unlikely used for hot beverages, as handleless vessels would burn the hands when pouring.

1 USNM ECC 121613

2 Walter Hough, "The Bernadou, Allen, and Jouy Korean Collections (HKC), in the U.S. National Museum," in *The U.S. National Museum Annual Report (USNM-AR) for 1891* (Washington, D.C.: Government Printing Office, 1892), 429-488.

3 Chang-su Cho Houchins, *An Ethnography of the Hermit Kingdom: The J.B. Bernadou Korean Collection 1884-1885* (Washington, D.C.: Asian Cultural History Program, National Museum of Natural History, Smithsonian Institution, 2004), 32.

72.
Bottle
18th–19th century, Joseon
TL results: *fired between 300 & 500 years ago*
Porcelain with underglaze cobalt decoration
H: 25.5 cm, W: 14.5 cm
Courtesy of Daewon Kwon and Chong J. Kwon

With bold and cursory brush strokes, this bottle is painted in cobalt blue with the "three friends of winter" motif—the pine and plum blossoms on one side, the bamboo on the opposite. It has a straight neck and drooping body. The footrim has been mostly wiped free of the bluish-tinted glaze and the base is mostly glazed, both with adhesions of kiln grit. Two small clay pads, or firing supports, have been left on the footrim after firing, possibly to help the bottle sit more evenly.

The "three friends of winter" are the pine, bamboo, and plum. They are symbols of strength and endurance in adverse conditions—the signs of a true gentleman. The pine and bamboo stay green during the winter, and plum blossoms are the first to bloom in the New Year.

An embroidered hunting scene, dating to the late eighteenth to early nineteenth century, in the Huh Dong Hwa Collection in Seoul, Korea depicts bottles similar to cats. 71-74 placed on the ground, underneath tables.[1] They were probably used to refill smaller bottles on the table when needed (see entry for cat. 71).

1 Hongnam Kim, ed., *Korean Arts of the Eighteenth Century: Splendor and Simplicity* (New York: Weatherhill: Asia Society Galleries, 1993), 76.

73.
Bottle
Second half of 19th century, Joseon
Porcelain with underglaze cobalt decoration
H: 26.3 cm, W: 16.3 cm

This bottle has a long, cylindrical neck and drooping, bottom-heavy body. It is decorated with sprays of chrysanthemums, flowers of luck, with petals and leaves rendered with individual strokes of the brush. The footrim has adhesions of kiln grit and the base is glazed.

The collector's mother used a similar bottle for pouring drinking water. This bottle was probably made in the Bunwon kilns.

74.
Bottle
19th century, Joseon
TL results: *fired between 150 & 250 years ago*
Porcelain with underglaze cobalt decoration
H: 20.3 cm, W: 12.4 cm

The body of this bottle is drooping and bottom-heavy. It is painted in blue with simple vegetal motifs in calligraphic brush strokes on either side of the vessel. The base is glazed, and the footrim has been wiped free of glaze.

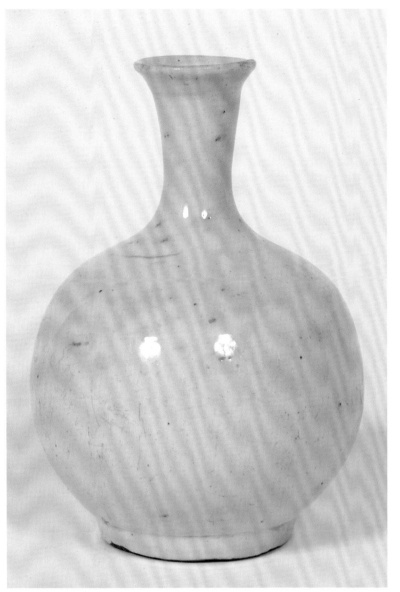

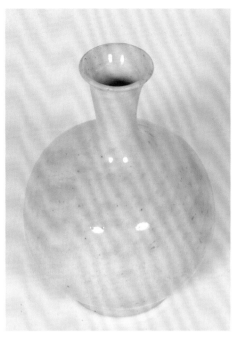

75.
Bottle
19th–20th century, Joseon
TL results: *fired between 100 & 200 years ago*
Porcelain
H: 20 cm, W: 14.5 cm

Coated in a clear glaze, this bottle has a trumpet mouth and neck attached to a spherical body. The base is glazed, and the footrim is unglazed. There are splotches of discoloration throughout the body.

Due to its smaller size, this type of bottle was likely used for holding alcohol.

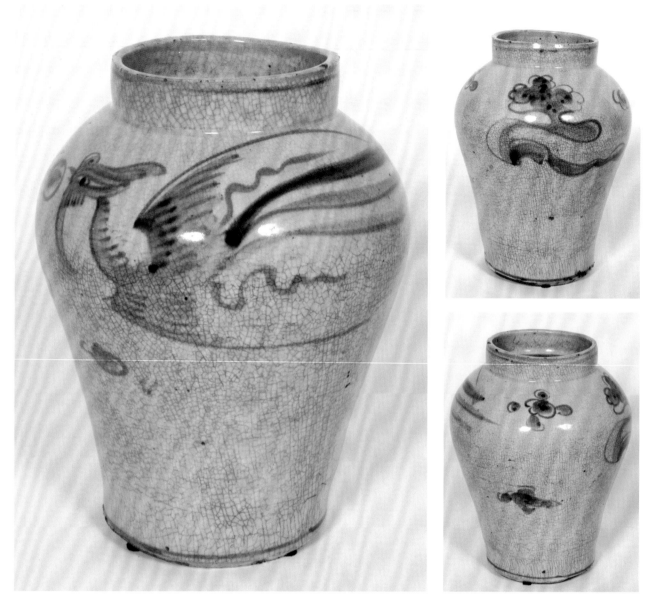

76.
Jar
18th–19th century, Joseon
TL results: *fired between 300 & 500 years ago*
Porcelain with underglaze cobalt decoration
H: 27.2 cm, W: 21 cm
Courtesy of Daewon Kwon and Chong J. Kwon

Painted with a phoenix flying amid clouds under a bluish-tinted glaze, this jar has rounded shoulders and a tapering waist. The base is glazed. The beveled footrim had been wiped free of glaze and has adhesions of kiln grit.

Phoenixes were another symbol that was imported to Korea from China. The mythical bird only appears in times of peace and was thought to announce the arrival of a righteous ruler or sage. These benevolent birds are thought to prefer perching on paulownia (Chinese parasol) trees or appear in bamboo groves, as they eat bamboo seeds—a rare food source, for most bamboos flower infrequently, some species flowering only once every one hundred years or more. This jar probably once had a matching lid.

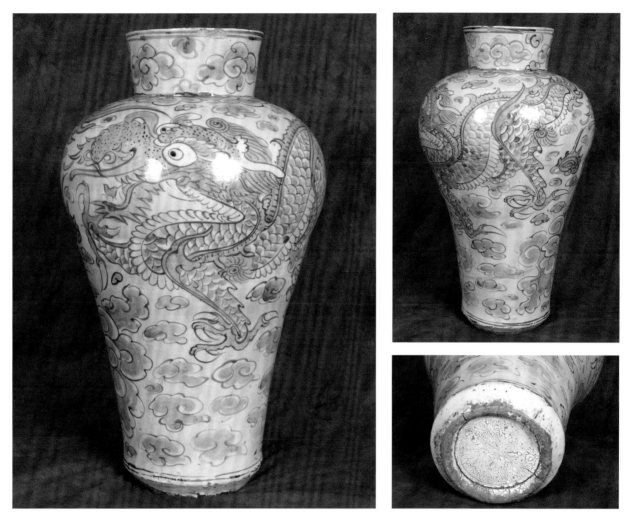

77.
Jar
Second half of 19th century, Joseon
TL results: *fired between 150 & 300 years ago*
Porcelain with underglaze cobalt decoration
H: 53.2 cm, W: 30.5 cm

This jar was made in three sections and luted together below the neck and about one third of the way down the body. The high, slightly flaring neck is painted with clouds. The beginning of the shoulder is collared with a ring of *yeo ui* (Ch: *rúyì*) heads and bulges outwards before tapering to the waist. A four-clawed dragon chasing a flaming pearl amid clouds encircles the jar. Outlined in dark blue, the cobalt painting is filled in with a paler wash. The footrim is beveled and has been wiped free of the blue-tinted glaze before firing. The base is glazed.

Dragons in Korea come from Chinese mythology and are among the most auspicious of creatures. They traverse air, land, and water and are bringers of rain—extremely important for a traditionally agricultural society. A matching lid was probably once associated with this jar, such as the example in cat. 78.

The collector's parents used this vessel as a flower vase. A painting commemorating the gathering of elderly statesmen, dating to 1719-20, in the collection of the Ho-Am Art Museum, Yongin depicts large blue and white jars, some with sprigs of flowers, placed on stands within the setting of a ritual.[1] Large jars such this vessel and cat. 78 may have been used in such settings, with the lid removed when used as flower vases.

1 Hongnam Kim, ed., *Korean Arts of the Eighteenth Century: Splendor and Simplicity* (New York: Weatherhill: Asia Society Galleries, 1993), 27.

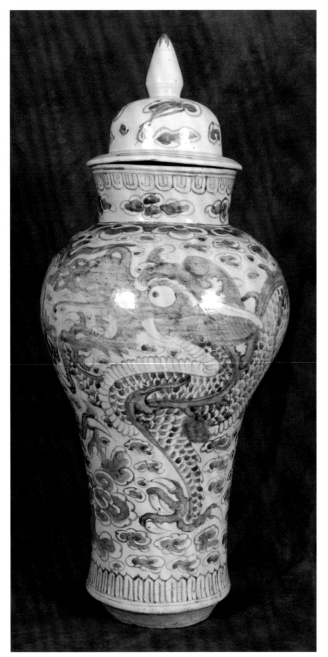

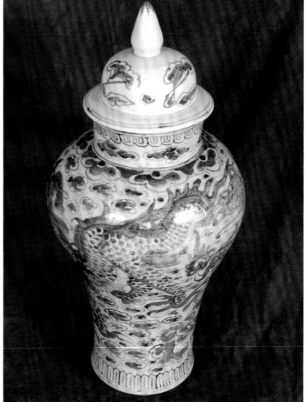

78.
Lidded jar
Second half of 19th century, Joseon
TL results: *fired between 200 & 400 years ago*
Porcelain with underglaze cobalt decoration
H: 67.5 cm (including lid), W: 28.5 cm

The two sections from which this jar was made were luted together about one-third of the way down the body. A large-headed, four-clawed dragon chasing a flaming pearl amid clouds is the main decoration. The relatively tall, flaring neck may also have been luted to the jar. It is painted with a band of lotus petals at the lip and a row of clouds just below. A collar of *yeo ui* (Ch: *rúyì*) heads encircles where the shoulder starts and the form bulges out and tapers to a waist before flaring gently at the foot. Another band of lotus petals is painted around the foot. The indented footrim is tall, beveled, and unglazed at the bottom. The bluish-toned glaze coats the deeply cut base. The lid is domed with a conical knob that is decorated with a stylized flower, probably a lotus, at the tip. The dome of the lid is painted with twisting clouds. The flat collar of the cover is decorated with two parallel lines that encircle the lid near the edge.

It is rare to find this type of jar with its original cover. Although difficult to say whether the lid associated with this jar is original, it is at least safe to say that this lid was originally intended for this type of dragon jar.[1] The reasons to question the original association of the lid and jar include the whiteness of the lid, which is brighter than the white on the jar, though this may be explained by inconsistencies during the firing process. The lid is more sparsely decorated than the jar and the flat collar also seems slightly too small in proportion to the mouth of the jar. The cobalt blue on the lid and the jar are the same tone.

1 For another example of a dragon jar with the same type of lid, see: Yong-i Yun, "Part III Punchŏng Wares and Porcelains of the Chosŏn Dynasty," in *Korean Art from the Gompertz and Other Collections in the Fitzwilliam Museum: A Complete Catalogue*, ed. Regina Krahl (Cambridge: Cambridge University Press, 2006), 274.

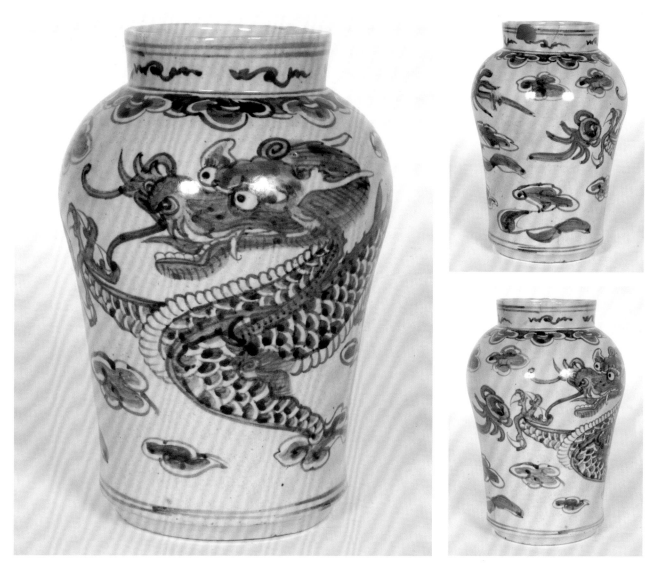

79.
Jar
19th century, Joseon
TL results: *fired between 150 & 300 years ago*
Porcelain with underglaze cobalt decoration and
silver lacquer repair
H: 25.5 cm, W: 17.4 cm

This jar is similar in form and decoration to cats. 77 and 78, though it lacks the exaggerated elongated features. The neck is decorated with stylized scrolls. The shoulder is collared with a ring of *yeo ui* (Ch: *rúyì*) heads and bulges outwards before gently tapering inward to form the waist. The body of the jar is decorated with a dragon chasing a flaming pearl amid clouds. Parallel lines are painted around the lip, where the neck and body meet, and just before the indented foot of the jar. The base is coated with the grayish, blue-tinted glaze, but the footrim had been wiped free of glaze. There is a silver lacquer repair on the lip.

According to Moes,[1] such dragon jars were made in pairs and meant to be placed in royal throne rooms or on altars of Confucian temples. A matching lid was probably once associated with this jar.

1 Robert Moes, *Korean Art from the Brooklyn Museum Collection* (New York: Universe Books, 1987), 154.

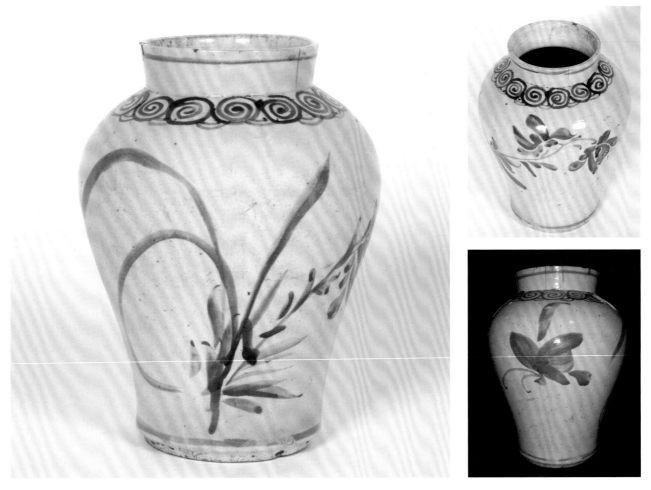

80.
Jar
18th–19th century, Joseon
TL results: *fired between 200 & 400 years ago*
Porcelain with underglaze cobalt decoration
H: 24.8 cm, W: 18.7 cm

Similar in shape to the jar decorated with a dragon in cat. 79, this jar has a flaring neck joined to a shoulder that bulges and then tapers towards the waist to form a base with an indented foot. "Chatter marks" radiating from the center of the base, caused by a potter's knife when trimming the foot, are apparent. The base is completely glazed, leaving the footrim free of glaze. Repeating spirals are painted in cobalt and encircle the shoulder, just under the neck. The body is decorated with an orchid plant and a butterfly in mid-flight.

The decorator painted by manipulating the forms of each brush stroke so that the impression of the subject matter was captured with a minimum of strokes—in the fashion of calligraphy and ink painting. The usual *yeo ui* (Ch: *rúyi*) collars surrounding the area below the neck on this type of jar have been simplified into a collar of spirals (compare with cats. 77-79). Presumably, this type of jar would have originally been equipped with a matching porcelain lid.

Butterflies are a symbol for happiness, blessings, and longevity. The word for butterfly in Chinese (from which the Korean language has incorporated many loan words) is a rebus for these three wishes. The insect is also a symbol for femininity. The collector's grandparents, parents, and wife have used this jar as a flower vase.

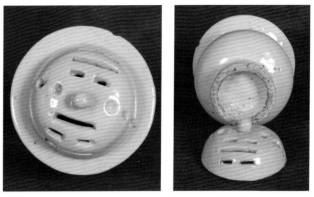

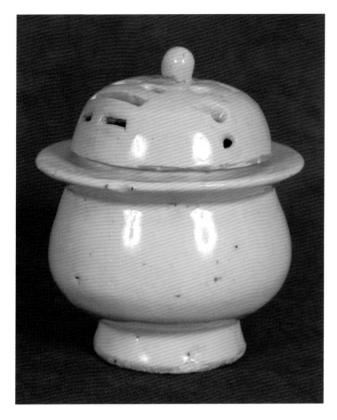

81.
Lidded incense burner
19th century, Joseon
TL results: *fired between 100 & 200 years ago*
Porcelain
H: 9 cm, W: 8 cm

The bulbous body of this small, white porcelain incense burner rests on a flared foot. It is topped with a disk-like lip and a short collar on which the lid rests. The cover is pierced with two sets of the Eight Daoist Trigrams (Kr: Palgoe, Ch: Bāguà) separated by a column of three pierced holes on each side. Some of the holes have not been pierced all the way through or have become blocked by glaze. The areas where the body of the vessel and lid come in contact with each other are unglazed. The base is glazed; the footrim is unglazed with adhesions of kiln grit. The exposed, unglazed areas of the body have oxidized to an orangish color.

Palgoe are ancient Chinese symbols that were used for divination. Their first literary mention was in the *Zuo Zhuan* (Ch), the earliest Chinese narrative history compiled no later than the fourth century BC. The "Classic of Changes" (Kr: Yeok Kyeong, Ch: Yì Jīng), dating to the third century BC, gives commentary on the eight different emblems. Each set of emblems, known as trigrams, consists of three parallel lines that are either broken (two short lines) or solid (one long line), symbolizing opposing forces. There are a total of eight different combinations of trigrams, thereby giving them the name, the eight trigrams.

The body of this vessel is based on Chinese metal incense burners. The lids of these types of censers are pierced so that smoke passes through the openings when incense is being burned inside. The associated natural phenomena and names of the two trigrams represented are fire (Kr: Ri, Ch: Lí) and water (Kr: Gam, Ch: Kǎn).

The collector recalls that the ceremonial objects in cats. 81-93 were stored and used in an ancestral hall (Kr: *sadang*, Ch: *cítáng*) between the central part of Jukdong Palace and the palace pond. As a child, he remembers seeing his grandparents using them regularly for ceremonies to commemorate their ancestors (Kr: *jesa*). They were brought to Los Angeles, CA in the 1950s by the collector's family and were used at least every three months when they first came to America due to the number of ancestors they regularly honored. The family would often take offering vessels such as these to a local Korean community Baptist church in Los Angeles to practice *jesa*. They were also lent out to other Koreans in the area.

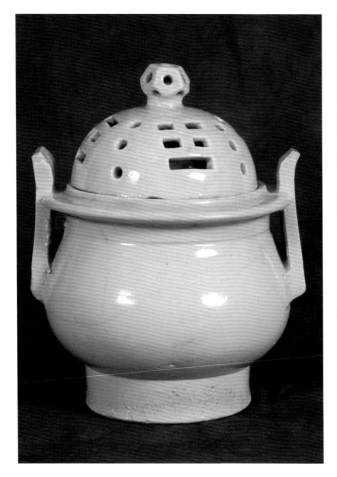

82.
Lidded incense burner
18th–19th century, Joseon
TL results: *fired between 250 & 400 years ago*
Porcelain
H: 18.2 cm, W: 14.3 cm

Of similar but larger and more elaborate form to cat. 81, the shape of this censer is derived from a Chinese bronze vessel form. The bulbous body of this white porcelain incense burner with blue-toned glaze sits on a relatively tall foot. Two flanges grow out from opposite sides of the body and connect to the flattened, disk-like collar encircling the lip. The flanges are incised with a line that follows the edges of the appendages and with abstract tendril-like scrolls in the center. The mouth of the vessel has a short collar on which the lip of the lid settles into. The lid is decorated with four sets of pierced Palgoe, separated by columns of three pierced holes. The knob is a polyhedron pierced by a hole on each side. The areas where the vessel and lid come into contact with each other are free of glaze. The glazed base has faint radiating "chatter marks" caused by the trimming of the foot with a potter's knife. The footrim is free of glaze and has a bit of kiln grit adhesions, as does the base. There are still remnants of incense resin on the underside of the lid.

The form of this censer is copied from a Chinese ceremonial vessel called a round *ding* (Ch), which has origins dating to the Chinese Neolithic period (*ca.* 6000–2000 BC). The associated natural phenomena and names of the four trigrams used to decorate the lid of this incense burner are as follows: thunder (Kr: Jin, Ch: Zhèn), water (Kr: Gam, Ch: Kǎn), lake/marsh (Kr: Tae, Ch: Duì), and fire (Kr: Ri, Ch: Lí). It is uncertain whether there was a reason for using these four specific trigrams. It is likely they were used mainly in reference to the Chinese classics and the trigrams' association with intellectual and spiritual pursuits. This incense burner was probably used within an ancestor altar setup. It would have been placed on a low incense table, together with an incense box, in front of the main altar setup and memorial tablet.

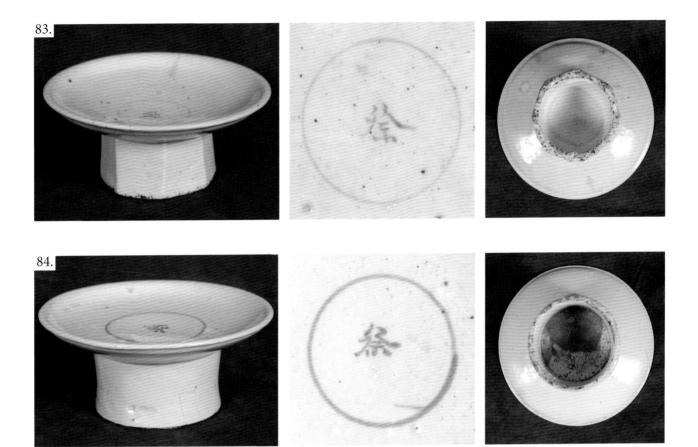

83.
Pedestaled offering dish
18th–19th century, Joseon
TL results: *fired between 250 & 400 years ago*
Porcelain with underglaze cobalt decoration
H: 7.4 cm, W: 16.7 cm

84.
Pedestaled offering dish
18th–19th century, Joseon
TL results: *fired between 250 & 400 years ago*
Porcelain with underglaze cobalt decoration
H: 6.7 cm, W: 15.6 cm

Known as *jegi* (sacrificial wares), these two pedestaled dishes have the Chinese character for "to offer sacrifice" (Kr: *je*, Ch: *ji*) written in cobalt blue in the center of the dish, enclosed within a circle. The tall foot is octagonal on cat. 83 and cylindrical on cat. 84. Both footrims have been wiped free of glaze and have adhesions of kiln grit.

Jegi were made from a variety of materials including wood and metal. However, white porcelain *jegi* were made for the sole purpose of being used in ceremonies commemorating ancestors (Kr: *jesa*). White was symbolic of purity and also of death and mourning. Fruits, sweets, or other foods would have been piled on these dishes as offerings for deceased family members. Traditionally, these wares were stored in ancestral shrines and had to be buried if broken. Koreans continue to practice *jesa* today but use mainly wood or metal offering dishes.

The collector explains that in addition to *jesa*, his family, starting in the 1950s, also used the offering dishes (cats. 83-91) during holidays, a person's sixtieth birthday (Kr: *hwangab*), and in recognition of the one hundredth day after a child's birth (Kr: *baegil*, Ch: *băirì*). After leaving Korea, the functions of many of the ceramics the collector's family brought to America eventually changed or expanded in order to meet the needs of a different social context.

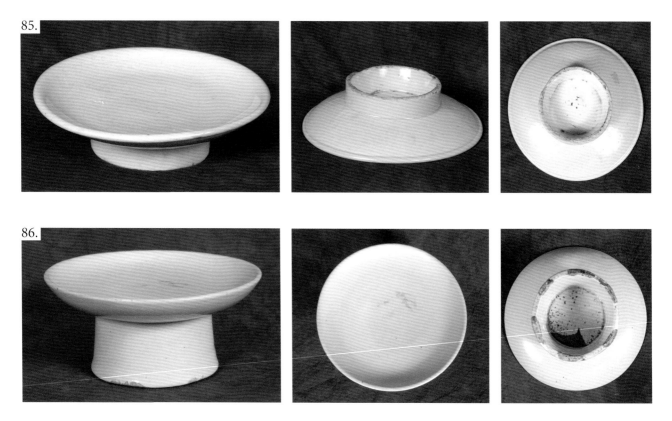

85.

Offering dish

18th–19th century, Joseon

TL results: *fired between 250 & 400 years ago*

Porcelain

H: 5.1 cm, W: 18.6 cm

86.

Offering dish

18th–19th century, Joseon

Porcelain

H: 6.6 cm, W: 14.6 cm

Lacking any decoration, these white porcelain offering dishes are raised on integral pedestals and coated with a clear glaze with greenish-blue tint. The footrim of cat. 85 is free of glaze. Kiln scars left by clay pads are visible on the footrim of cat. 86.

Steeped in Neo-Confucian ideology, the elite *yangban* ruling class of the Joseon dynasty often preferred the austere look of plain white porcelain over decorated wares, especially for paraphernalia associated with ancestor ceremonies. Offering vessels used for such ceremonies were raised on pedestals to show respect to the ancestors and reinforce their elevated status.

87.

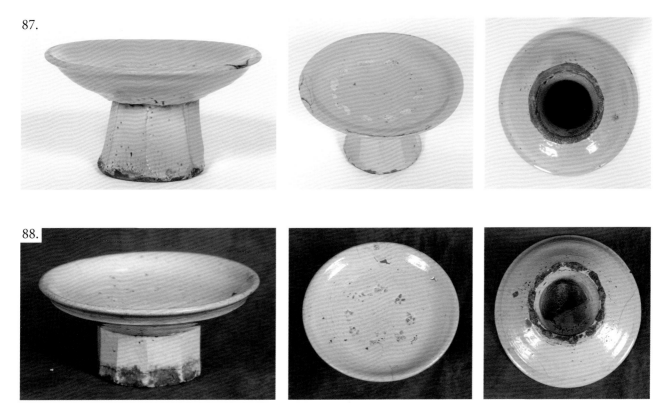

87.
Offering dish
19th century, Joseon
TL results: *fired between 200 & 400 years ago*
Porcelain
H: 7.5 cm, W: 13.7 cm

88.
Offering dish
19th century, Joseon
TL results: *fired between 200 & 400 years ago*
Porcelain
H: 6.7 cm, W: 15 cm

These two offering dishes are raised on faceted pedestals. Catalogue 87 has nine facets and cat. 88 has eleven facets. An abundance of kiln scars can be seen inside the dishes of both vessels and on the footrim of cat. 88. The footrim of cat. 87 is unglazed. The exposed portions on the body of cat. 87 have oxidized to an orangish color during the firing process.

Although the firing scars on the dishes may seem to be obvious blemishes, they would have been covered up when offerings of food were neatly stacked on top. The many clay pads used to separate the vessels during firing suggest they are products of kilns in the southern part of Korea.

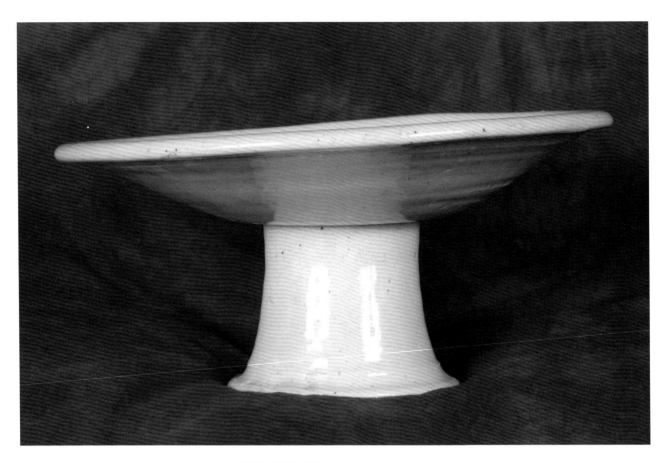

This large dish is raised on a flaring foot. There are a total of twelve firing scars on the footrim, which is otherwise glazed.

The copious amount of kiln scars left by clay pads seen on the footrim indicates this vessel was probably made at a kiln in the southern part of Korea. The size of this dish is larger than most offering dishes.

89.
Large offering dish
19th century, Joseon
Porcelain
H: 12.7 cm, W: 25.7 cm

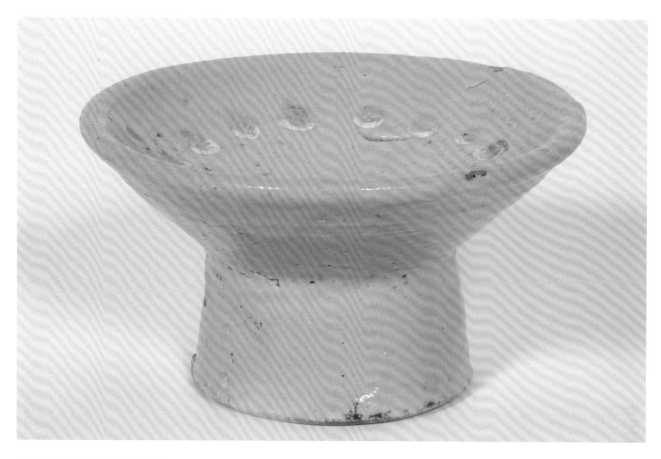

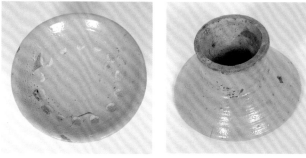

The dish of this offering vessel is deeper than most. It has a total of fourteen kiln scars on the inside of the dish left by clay pads used to separate this piece from another piece during firing inside the kiln.

The profuse amount of kiln scars on the top surface of the dish suggests it was made at a kiln in the southern part of Korea.

90.
Offering dish
19th century, Joseon
TL results: *fired between 150 & 300 years ago*
Porcelain
H: 6.3 cm, W: 11.7 cm

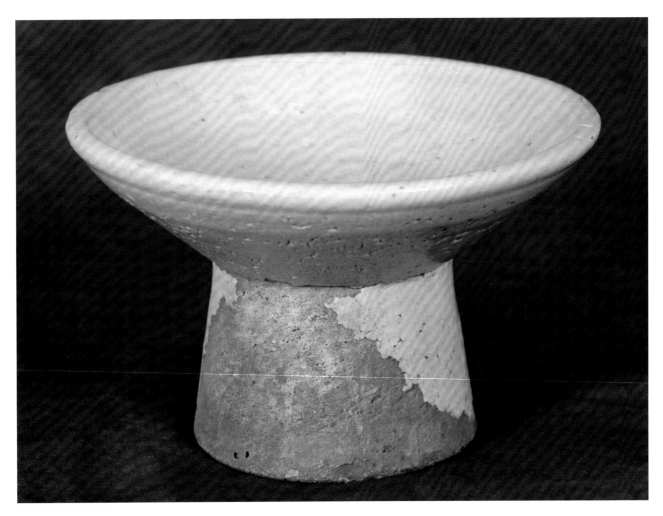

Similar in form to cat. 90, the deeper dish of this offering vessel is attached to a high, flaring foot. The opaque, cream-colored glaze on part of the lip of this dish has pulled away to reveal the body material, and much of the glaze has also flaked away on the pedestal foot. The glaze on the underside of the dish has a curdled texture.

The flaking and pulling away of the glaze on this offering dish is due to misfiring. The deeper well of this vessel and cat. 90 suggest they may have been used for holding a particular type of food offering.

91.
Offering dish
18th–19th century, Joseon
TL results: *fired between 100 & 300 years ago*
Porcelain with cream-colored glaze
H: 9.5 cm, W: 15.5 cm

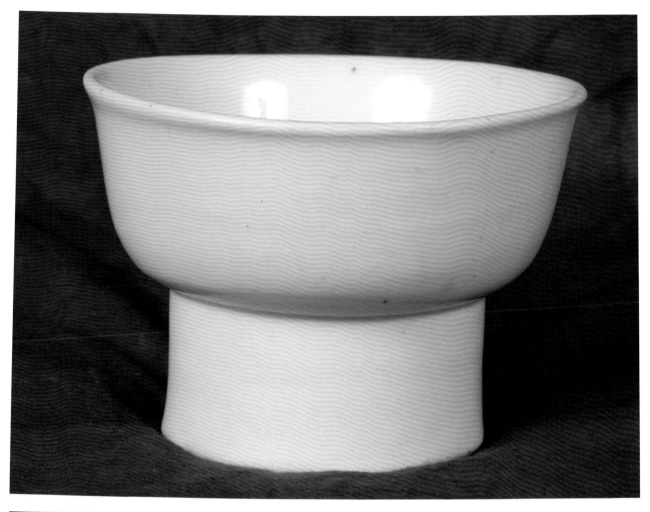

This bowl, raised on a high, cylindrical foot, is undeco-rated and coated in a blue-tinted glaze. The footrim is free of glaze.

Used during Confucian ceremonies for ancestors, *baekja* (white porcelain) pedestaled bowls, such as this, held offerings of soup. This vessel is likely a product of the Bunwon kilns.

92.
Offering bowl for soup
19th century, Joseon
TL results: *fired between 200 & 400 years ago*
Porcelain
H: 9.7 cm, W: 13.9 cm

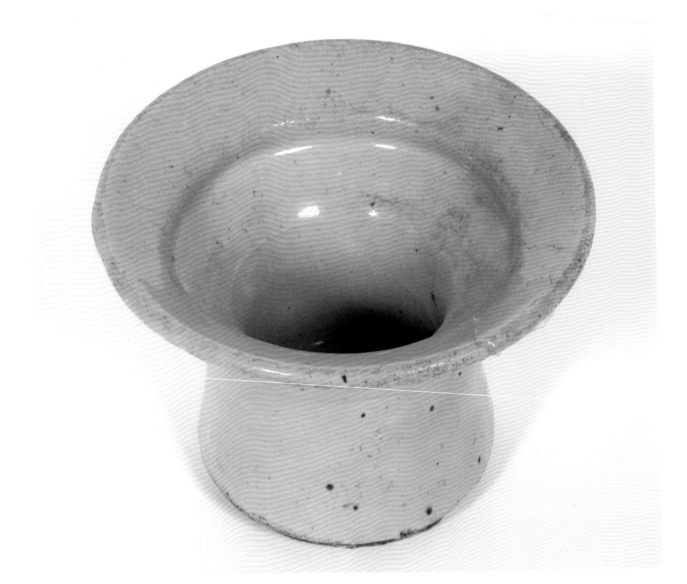

Made of undecorated white porcelain, the lip of this cup stand indents into the mouth in order to give a more snug fit for the stem cup that would have slotted into this stand. The footrim has been wiped free of the grayish-toned glaze and has adhesions of kiln grit. The base is glazed.

93.
Ceremonial cup stand
18th–19th century, Joseon
TL results: *fired between 200 & 400 years ago*
Porcelain
H: 7.9 cm, W: 11.9 cm

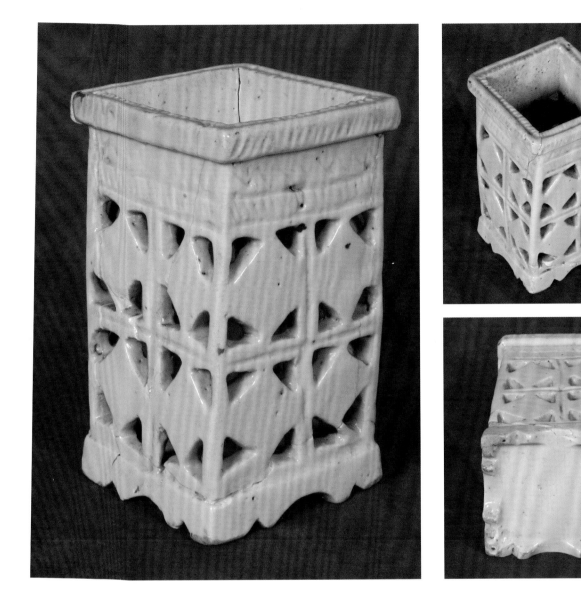

94.

Brush container

18th–19th century, Joseon

TL results: *fired between 300 & 500 years ago*

Porcelain

H: 14.3 cm, W: 9 cm

This four-sided white porcelain brush container is incised on the protruding lip and top quarter of the vessel with repeating diagonal lines and a triangular dog-tooth pattern that is similar to the dog-tooth pattern on the Unified Silla jar in cat. 7. The main section of the body is quartered and pierced to reveal four lozenges on each side. The foot is carved in a way that imitates aprons found on wood furniture or other types of woodwork. The base is coated in the grayish-toned glaze, but the footrim is free of glaze.

Containers such as this were used for holding writing and painting brushes. Together with paper, ink, and inkstone, brushes were considered one of the Confucian scholar's "four treasures of the scholars' studio" (Kr: *munbang-sabo*, Ch: *wénfáng sìbǎo*). The collector reports that this piece and the following collection of calligraphy and painting related tools (cats. 95-100 & 102) were owned by his great grandfather, Min Young Whe (1852-1935). Stationery for scholars reached a peak in popularity during the eighteenth and nineteenth centuries.

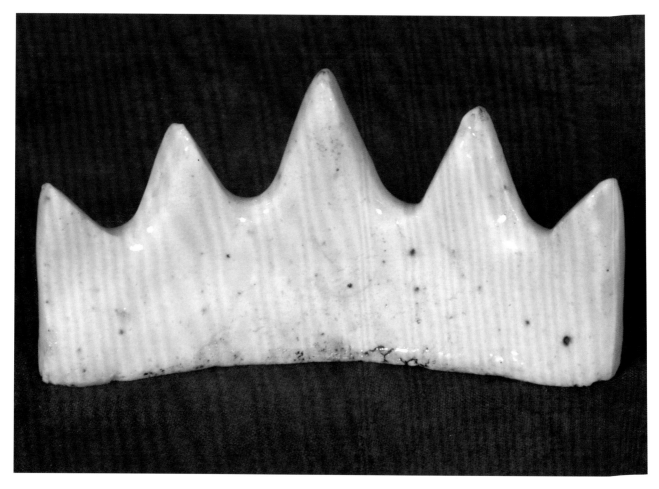

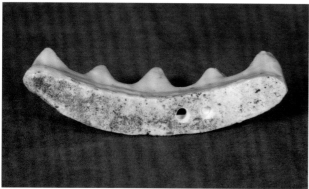

95.
Brush stand
18th–19th century, Joseon
TL results: *fired between 250 & 350 years ago*
Porcelain
H: 4.6 cm, W: 9 cm

This piece of scholars' stationery is slightly curved with five pointed peaks and coated in a bluish-toned glaze. The base is unglazed, revealing the oxidized orangish surface of the body material.

Each half made in mold, the seam of this brush stand is apparent along the peaks. It has a hollow space inside, as can be seen through the hole from which the thermoluminescence test sample was extracted. The bluish tone of the glaze is due to its iron content and suggests it was made after the middle of the eighteenth century.

The handle of a brush, just before where the hairs start, would temporarily rest between two of the peaks of this brush stand when the calligrapher/painter was not using the wet brush, in order to prevent ink from smudging onto the surface of the table. The standard five peaks design of this brush stand comes from China, where the peaks represent the Five Sacred Mountains. More elaborate examples of Korean water droppers and brush stands, dating to the nineteenth century, exist and are said to be representations of the Diamond Mountains (Kr: Geumgangsan),[1] located in present-day North Korea. The mountains have long been admired for their natural beauty in both Korea and China.

1 Pierre Cambon and Joseph P. Carroll, *The Poetry of Ink: The Korean Literati Tradition, 1392-1910.* (Paris: Réunion des Musées Nationaux, 2005), cats. 40, 41, 45, 46.

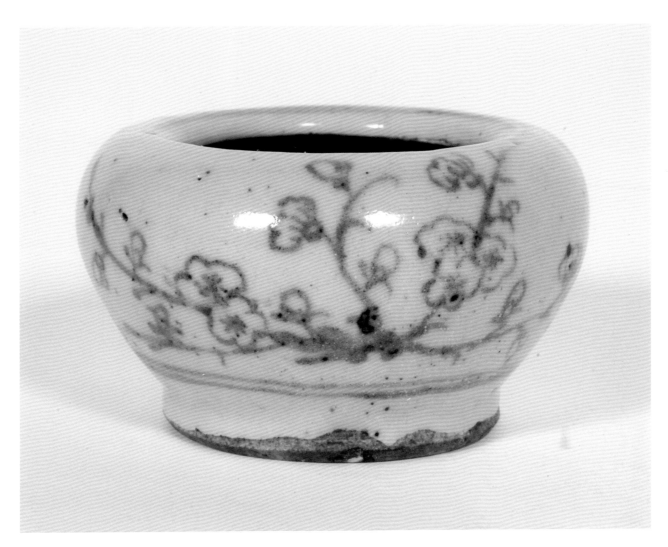

96.
Water pot
18th century, Joseon
Porcelain with underglaze cobalt decoration
H: 4 cm, W: 6.6 cm

Similar in shape to a miniature Buddhist alms bowl, this water pot has a lip that turns inwards and broad shoulders that taper to a waist and a flat, unglazed base. The surface is decorated with a branch of plum blossoms painted in cobalt blue. Double rings circle the mouth and just above the foot.

Water pots have the same function as water droppers, except a miniature ladle is used to scoop water onto the inkstone instead of dripping it on directly from a water dropper. The first to flower each year, plum blossoms stand for perseverance and purity—characteristics of an ideal Confucian scholar. The five petaled flower also stands for the "five blessings" (Kr: *obok*, Ch: *wǔfú*): longevity, wealth, health, love of virtue, and natural death.

97.

Water dropper

Second half of 18th–19th century, Joseon

TL results: *fired between 200 & 350 years ago*

Porcelain with underglaze cobalt and iron oxide decoration

H: 8.5 cm, W: 6.5 cm

This peach-shaped water dropper is held upright on an integral base molded into the shape of a coiled twig, which stems up the back cleft of the peach and forms the spout of the vessel. A venting hole is located along the cleft on the front of the peach. Two leaves grow out from each side of the twig base, and the sides of the peach are decorated with four blossoms. The leaves are decorated in cobalt blue; and the blossoms, spout, and tip of the peach are decorated in iron-brown. The underside of the base is covered with the remains of kiln grit. A small object can be heard rattling inside the water dropper when it is picked up.

The venting hole along the front cleft of the peach is used to control the flow of water from the spout with a finger. The small object inside the water dropper may help to slow down the flow when pouring water onto an inkstone.

Peaches are associated with the Daoist attainment of immortality and have sexual connotations, which some Korean potters made use of by exaggerating the features of a peach. They are often featured in Korean art as one of the symbols of longevity. According to Chinese mythology, the Queen Mother of the West (Ch: Xī Wáng Mǔ, Kr: So Wang-mo) had an orchard that contained peaches which would ripen once every three thousand years. Once consumed, it would grant mortals immortality. The five petals of the peach blossoms represent the "five blessings" (see cat. 96).

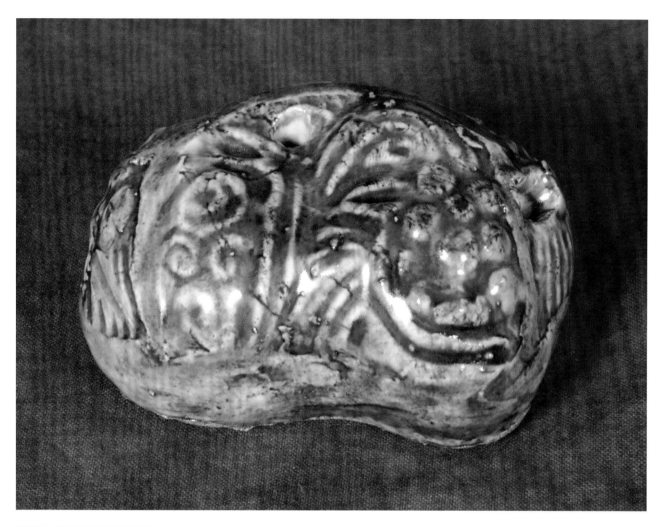

98.
Water dropper
19th century, Joseon
Porcelain coated with underglaze cobalt decoration
H: 3.8 cm, W: 7 cm

This water dropper is molded in the form of a *haetae* and coated in underglaze cobalt blue pigment. The hole from which the water is poured is located in the left ear of the mythical creature and the hole controlling the water flow is situated on its back.

Haetae are mythical creatures with many auspicious attributes. Among them include the ability to repel fire and protect against all forms of disruptive change. Their images in stone can be found in Korean palaces and act as guardians.

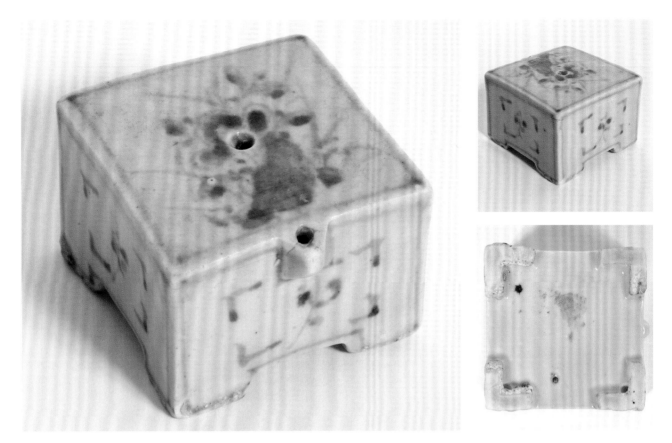

99.
Water dropper
19th–early 20th century, Joseon
Porcelain with underglaze cobalt decoration
H: 4.5 cm, W: 6.8 cm (with spout)

With the spout in the center of one edge and the venting hole on the top center, this cuboid water dropper rests on four feet, one on each corner. The top is painted with a flower, probably an orchid, growing next to a rock. The four sides are painted with abstract floral motifs, each framed by four brackets in the corners. The base is glazed. The bottoms of the feet are unglazed with small amounts of kiln grit adhesions.

A water dropper is a tool of the scholar, used to pour small amounts of water with which an inkstick is ground to make ink on the surface of an inkstone. These would have been located in the study of a Korean house reserved for men called a *sarangbang*.

100.
Water dropper
19th–early 20th century, Joseon
TL results: *fired between 250 & 350 years ago*
Porcelain with underglaze cobalt decoration
H: 3.5 cm, W: 8.5 cm (with spout)

This doughnut-shaped water dropper has a hole that goes through the center of the vessel. The cobalt blue painting of a scene of mountains and water on the top is outlined in dark blue and filled in with a lighter blue wash. The spout of the brush washer is located in the top edge of the vessel, and the venting hole is located on the top surface of the opposite side. On the side of the water dropper are written the Chinese characters meaning "sky" (Kr: *cheon*, Ch: *tiān*), "one" (Kr: *il*, Ch: *yī*), "to be born" (Kr: *saeng*, Ch: *shēng*), and "water" (Kr: *su*, Ch: *shuǐ*). The base is glazed, and the footrim is unglazed.

The scene depicted on this water dropper is one that is commonly depicted on small scholars' articles produced at the Bunwon kilns during the nineteenth and early twentieth centuries. The official kilns moved to the banks of the scenic Han River in 1752. Objects painted with a scene of the river were often sold to and commissioned by learned sightseers traveling along the river.[1] The writing on the side refers to a passage in the ancient Daoist text, the "Classic of Changes" (Ch: Yì Jīng, Kr: Yeok Kyeong), and reveals that water was the first creation by heaven.

1 Gompertz, *Korean Pottery and Porcelain of the Yi Period*, 22.

Shaped like a disk with a hole that pierces through the center of the body, the top surface of this water dropper is painted with the Chinese genre of a landscape of mountains and water (Kr: *sansu-do*, Ch: *shān shuǐ tú*). The sides are straight and decorated with abstract scrolls. The venting hole is located on the top of the landscape scene, camouflaged by the painting of a mountain. A small spout from which the water flows is located on the opposite edge. The water dropper rests on a footrim which is free of glaze.

101.
Water dropper
19th–early 20th century, Joseon
Porcelain with underglaze cobalt decoration
H: 3.5 cm, W: 8.2 cm (with spout)

102.
Water dropper
19th–early 20th century, Joseon
Porcelain with underglaze cobalt decoration
H: 2.9 cm, W: 10.8 cm

Painted with a typical landscape scene of mountains and water (Kr: *sansu-do*, Ch: *shān shuǐ tú*), this water dropper has the outline of a fan. The sides of the water dropper are decorated with cursorily painted scrolls. The spout is located at the far left, top corner of the small vessel, while the venting hole resides at the top center. The base is flat and left unglazed, and the unglazed surface of the biscuit is an orangish color.

Water droppers were used to add water to the inkstone when grinding sticks of ink for painting or writing calligraphy. The consistency of the ink was important for creating different effects, and controlling the amount of water that was added onto the inkstone was therefore crucial. The literati often used fans, the form that this water dropper takes, as painting surfaces. The orangish color of the biscuit is due to oxidization during the firing process.

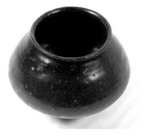
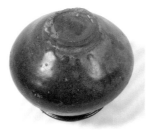

103.
Jar
15th–16th century, Joseon
Stoneware with brown glaze
H: 10.5 cm, W: 14.6 cm

The profile of this brown-glazed, wide mouthed jar resembles two bowls attached together at the mouths. The footrim and base were left unglazed, with kiln grit covering nearly half the footrim. The exposed body of the base and footrim has fired to a reddish color.

Iron glazes can range from dark brown to nearly black. The higher the iron content of the glaze, the darker the color. The same element in the body material oxidizes to a reddish color, which can be seen on the unglazed areas of this jar. This characteristic, together with the potting style of the body, suggest this jar was also a product of the kilns near Mount Gyeryong in South Chungcheong Province. There, remains of iron-glazed wares are most prominent but also include fragments of white porcelain along with *buncheong* wares decorated with iron oxide over white slip,[1] such as cat. 48.

1 Gompertz, *Korean Pottery and Porcelain of the Yi Period*, 71.

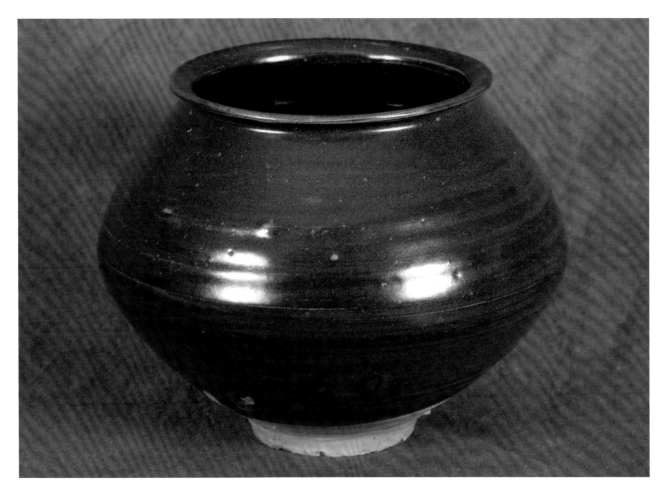

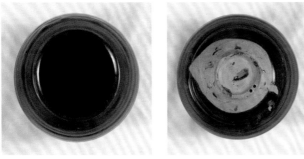

Similar in shape and glaze color as cat. 103, this jar has a buff-colored body material. The iron glaze stops about three centimeters above the foot. Smudges of glaze left by the fingers of the glazer can be seen on the exposed body.

It has been suggested that this type of jar was used for serving soups or stews.[1]

104.
Jar
15th–16th century, Joseon
TL results: *fired between 400 & 700 years ago*
Stoneware with brown glaze
H: 13.4 cm, W: 17.5 cm

1 Yong-i Yun, "Part III Punchŏng Wares and Porcelains of the Chosŏn Dynasty," in *Korean Art from the Gompertz and Other Collections in the Fitzwilliam Museum: A Complete Catalogue*, ed. Regina Krahl (Cambridge: Cambridge University Press, 2006), 248.

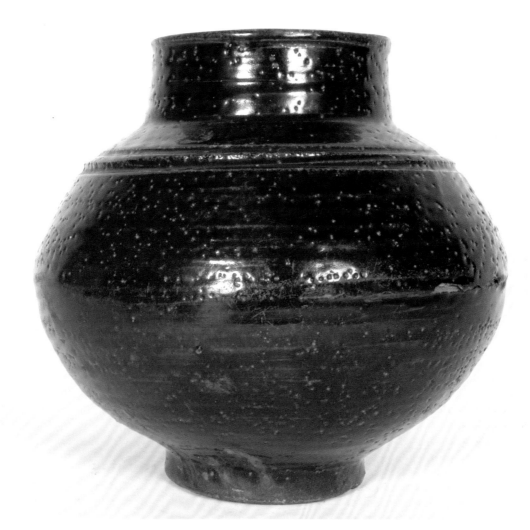

105.
Jar
18th–19th century, Joseon
TL results: *fired between 300 & 500 years ago*
Stoneware with brown glaze
H: 25.5 cm, W: 26.5 cm

This jar has a relatively tall neck with a slightly protruding lip. It was made in two halves, top and bottom, and luted together at the middle before firing. Two parallel impressed lines decorate the shoulder. The dark brown glaze is covered with small dimples caused by bubbles bursting in the glaze during firing. Smudges left by the fingers of the person who glazed the jar can be seen near the foot. The footrim and base are mostly free of glaze.

"Black-" and brown-glazed wares have been made in Korea since the beginning of the twelfth century and were generally used by commoners. Admired for their earthy, natural appearance, these humble wares have influenced modern potters in both Japan and the West.

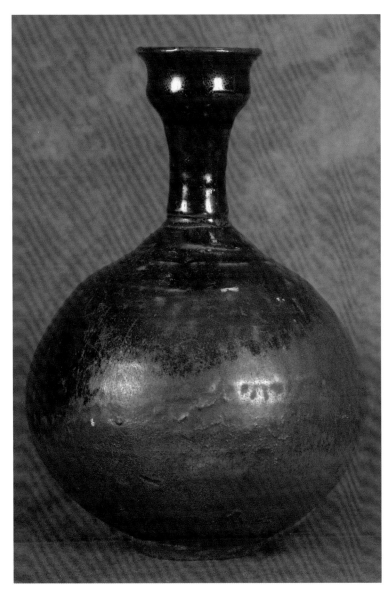

106.
Bottle
19th century, Joseon
TL results: *fired between 200 & 300 years ago*
Stoneware with brown glaze
H: 22.3 cm, W: 16 cm

With a mouth reminiscent of Goryeo period dish-shaped mouths, this bottle has a slender neck and spherical body that rests on a small footrim. The glaze is thickest at the mouth and neck of the vessel, running thinner further down the body, and stops before reaching the footrim. Certain areas left unstained on the base reveal a buff-colored body.

These types of bottles were used for storing oil for lamps and were made from the late Joseon dynasty into the twentieth century. Those made from white porcelain are also known and were probably used for ceremonial occasions.

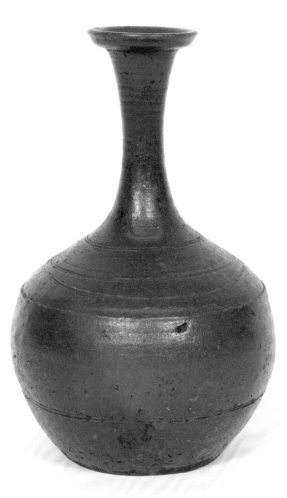

107.
Bottle
19th century, Joseon
TL results: *fired between 150 & 300 years ago*
Stoneware with brown glaze
H: 26.7 cm, W: 18 cm

Coated in brown glaze, the protruding lip of this *onggi* ware bottle indents and tapers into a tall, narrow neck before opening into a spherical body with a flat base. Simple incised lines adorn the body. The body material is an orangish color.

One of the lines that runs around the shoulder is actually a firing scar, probably from another object that rested around the shoulder of this bottle while being fired in the kiln. After firing, the glaze vitrified so the point of contact had to be broken between the two pieces, therefore causing a firing scar.

The production of *onggi* wares began no later than the eighteenth century,[1] but may have their roots extending beyond the Goryeo dynasty.[2] The humble ceramics were usually made into objects for daily use, such as condiment containers, and are perhaps best known for the large vats (see cat. 108) used for making kimchi (Korean pickled foods).

1 Beth McKillop, *Korean Art and Design* (London: Victoria and Albert Museum, 1992), 92.

2 Robert Sayers and Ralph Rinzler, *The Korean Onggi Potter* (Washington, D.C.: Smithsonian Institution Press, 1987), 19.

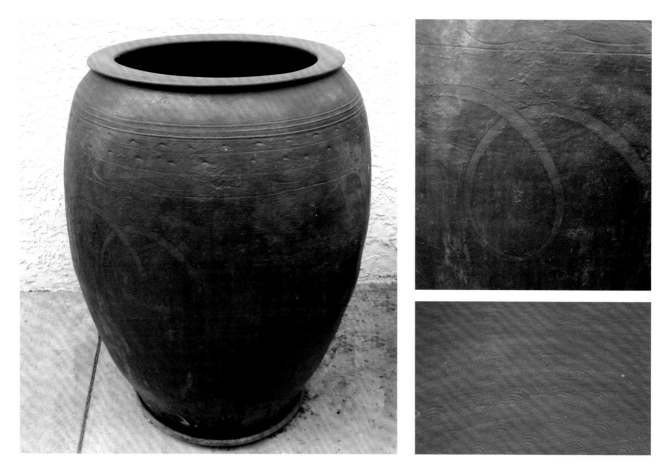

108.
Vat
19th–mid 20th century, Joseon–Modern
Stoneware with brown glaze
H: 101.5 cm, W: 75 cm

This large *onggi* ware vat has a reddish body material and is coated with brown glaze. It is simply decorated with raised and incised lines, impressed dimples, and spirals made by running a finger through the glaze while it was still wet. The inside of the jar has impressions of concentric rings and is thinly brushed with glaze. The base is flat.

Large jars, like this, were too cumbersome to make by throwing on a potter's wheel. Instead, these containers were made by building up the bodies with concentric coils of clay until the desired height was reached. A paddle was then used to strike the outside of the jar, with an anvil supporting the inside, until the desired shape was obtained. Impressed concentric circles inside this jar are caused by the design on the anvil. A large plate, or basin-like lid would have been used to cover the mouth of the vat.

The humble *onggi* ware was used by all levels of society in premodern Korea and well into the twentieth century. These wares come in a vast array of shapes and sizes and were an essential part of Korean food culture. Such large jars would have been used for purposes such as water or food storage. When used for pickling foods, called kimchi, these containers were buried in the ground during winter, with only the tops exposed, to create an ideal and constant temperature for pickling. Today, these utilitarian wares are being replaced by commercially made products. Even the making of kimchi, for which the *onggi* jar was once essential, is being carried out with the use of electric kimchi refrigerators.